ENGLISH SILVER

The Jerome & Rita Gans Collection

Addendum

by
John Culme

VIRGINIA MUSEUM OF FINE ARTS

Richmond, Virginia • 1999

The publication of this book was made possible by a generous grant from Mrs. Jerome Gans

ISBN 0-917046-55-4

Printed in the United States of America.

Produced by the Office of Publications, Virginia Museum of Fine Arts,
 2800 Grove Avenue, Richmond, Virginia 23221-2466 USA.

Curatorial Liaison: Kathleen M. Schrader
Project Director: Monica S. Rumsey
Project Editor: Emily J. Salmon
Research Assistant: Lee Anne Hurt
Book Design by Kenny Kane, Kane Design, Richmond, Virginia
Photography of Gans Collection silver objects by Katherine Wetzel.
Type set in New Caledonia.
Composed by the designer on the Macintosh using QuarkXPress.
Printed on Potlatch, Vintage Gloss, cover and Vintage Velvet, text
 by Cadmus Graphic Solutions, Sandston, Virginia.
Binding by Binding Technology, Inc., Nashville, Tennessee.

Front cover: Paul de Lamerie, *Pair of Figural Candlesticks*, sterling silver, 1748–49
(See Catalogue Number 2, page 36)

Contents

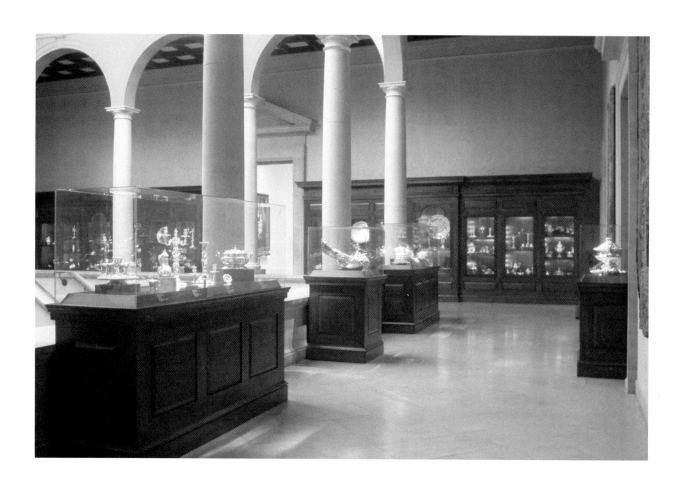

Foreword

In 1987, Rita and Jerome Gans introduced themselves to my predecessor, Paul Perrot, and offered to put their extraordinary collection of English silver on extended loan at the Virginia Museum of Fine Arts. This loan was the beginning of a long and productive collaboration between the museum and two visionary collectors.

My own acquaintance with the Ganses and their marvelous silver began with my arrival in 1991. As part of their ongoing involvement with the museum, the Ganses sponsored the 1992 publication of a catalogue of their collection, written by Joseph Bliss, former Assistant Curator of European Decorative Arts. During the next several years, they continued to collect silver and to add the newly acquired pieces to the display here in Richmond. Following the death of Jerome Gans in 1996, Rita Gans decided that the collection should be housed permanently at the Virginia Museum of Fine Arts. Her extraordinary gift included every piece that had been on loan here over the years.

No sooner had the gift been made than Mrs. Gans proposed two further projects: first, the creation of a special educational display based on the silver collection and aimed at children, families, and general visitors; and second, the publication of an addendum to the 1992 catalogue featuring objects that had not been included in the original catalogue. The "Discover Silver" gallery, which opened in October 1998, and the present catalogue addendum are testaments to Mrs. Gans's generous support, enthusiasm, and passion for sharing her collection with a broad audience. The staff of the Virginia Museum of Fine Arts have devoted their expertise to realizing these projects with the kind of elegance inspired by Rita and Jerome Gans themselves and by their remarkable collection.

The topic of silver is as rich as the metal itself. In his introduction to this catalogue, noted scholar John Culme gives us fascinating glimpses into the London silver trade and the society that supported it. His catalogue entries add to our knowledge and appreciation of the making and use of particular objects. Both perspectives—the broad and the focused—illuminate the appeal of silver to museum visitor and collector alike.

Collectors and museums need each other. The museum can offer collectors a lasting home for their collections–a place in which the objects can be appreciated by a wide public, and in which they will be cared for in perpetuity. In return, the museum and its public benefit from the passion and dedication of collectors, who spend years—sometimes a lifetime—in building their collections. Our museum's entire art collection is rich in history – of individual objects, of collectors, and of relationships, past and present. The story of the Gans collection is a remarkable part of the museum's history. Through their exacting standards in forming their collection, and through their generosity in donating it, Jerome and Rita Gans have left a legacy to be enjoyed by all who visit our museum.

Katharine C. Lee
Director

Preface

The Gans Collection of English Silver

Jerome and Rita Gans began collecting English silver relatively early in their adult lives. From the beginning, their enthusiasm was absolute and unbounded, with a penchant for objects of the highest quality dating from the late seventeenth century to the third quarter of the nineteenth. As John D. Davis wrote in his Introduction to the main catalogue of the Gans Collection, the couple's passion for English silver was imbued with "a highly discriminating sense of focus and selection."[1] Indeed, the style and quality are consistent throughout the collection, from the massive chased ginger jar of 1693–94, a masterpiece of Anthony Nelme's establishment,[2] to items of the mid-Victorian period from the Crown Jewellers R. & S. Garrard & Co. (FIGURE 1). The latter comprise various charming figural salt cellars,[3] some recently acquired,[4] and the rare eighteen-carat gold teapot of 1867–68.[5] This volume covers those objects acquired by the Ganses since the publication of the first book on the collection in 1992.

Perhaps the most remarkable feature of the Gans Collection is its sculptural character: the Nelme jar and the Garrard salt cellars are among an entire assemblage of objects whose chief purpose is not necessarily to perform a practical function but to delight and astonish the eye. Traditionally, richly worked silver and silver-gilt were the vehicles by which men of substance in many walks of life—princes, aristocrats and merchants—were

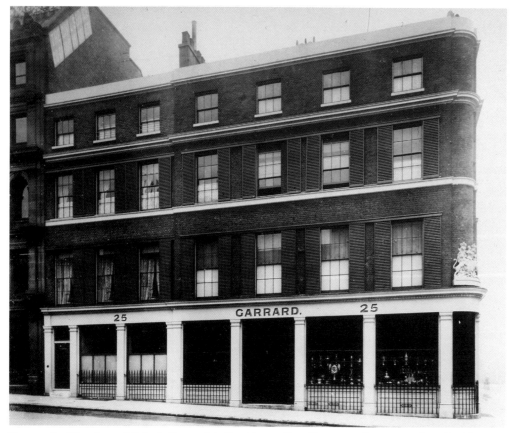

FIGURE 1. *The shop of R. & S. Garrard & Co., Crown Jewellers*, manufacturing and retail goldsmiths, silversmiths, and jewelers, dealers in antique silver, and so forth, 25 Haymarket, corner of Panton Street, London, W. From a photograph taken on Wednesday, 8 June 1898. These premises probably date from the late eighteenth century. (*Photo courtesy Westminster City Archives, London*)

able to reinforce and refine their standing in society. An extreme example was the use to which the seventeenth-century czars of Russia put their extensive holdings of Dutch, English, and German silver. Many of these objects were for display only and were often so large as to be literally useless. When viewed en masse, however, they filled any visitor on his way to the imperial presence with an overwhelming sense of awe.[6]

To some extent this need to declare one's wealth and station in the form of costly plate prevailed in various English private houses right into the early years of the twentieth century. After the 1860s the custom even drifted across the ocean to North America, where railway barons and industrialists bolstered their patriotic pride with extravagant purchases from the leading American goldsmiths, Tiffany & Co. and the Gorham Manufacturing Co.[7] In India the fashion lasted even longer: the fabulously wealthy Sir Bhupindra Singh, Marharaja of Patiala, ordered an extensive silver and silver-gilt dinner service from London as late as 1921.[8] Today the practice lingers on in England, where the British Royal Collection of silver as well as the collections of some of the older colleges of Oxford and Cambridge and the great City of London livery companies are often used at official functions. The Worshipful Company of Goldsmiths probably has the richest collection, which includes examples from mediaeval times to the present. Their impressive Paul de Lamerie ewer and dish, commissioned directly from the goldsmith in 1742, is a classic piece in the Rococo style as it evolved in England.[9]

It is no coincidence that among Mrs. Gans's favorite works are those that originated in de Lamerie's shop. They fulfill all the criteria that she and Mr. Gans sought for their collection: inventive in design, generous in execution, and attentive to detail in finish. Among the recent additions of de Lamerie to the Gans Collection are a pair of two-light candelabra dating from 1736–49[10] and a small Turkish-coffee pot of 1749–50.[11] It is no coincidence, either, that the Gans Collection as a whole is composed exclusively of London-made objects. After all, in the period under discussion, the capital was the center of a vigorous luxury-goods trade and the heart of a growing and powerful industrial nation and colonial empire. Even so, Mr. and Mrs. Gans had no intention of building a comprehensive London collection, except insofar as the pieces they have chosen represent among the very best of what was available to those earlier generations. It has to be said that this is a brave and praiseworthy approach in the highly complex market for antiques from a period when the idiosyncrasies of fashion and the depth of contemporary pockets dictated many parallel styles and a plethora of goods, ranging in accomplishment from exceptional to merely pedestrian. It takes a good eye and patience to distinguish one from the other, and in this task Mr. and Mrs. Gans were highly successful. What they have given to visitors of the Virginia Museum of Fine Arts is not only a truly wonderful collection of English silver of the eighteenth and early nineteenth centuries (beautifully displayed and maintained), but also a glimpse into the world of a few of our ancestors. —J.C.

Acknowledgments

This book would not have been possible without the vision, encouragement, and guidance so generously provided by Mrs. Jerome Gans, the wholehearted project support of museum director Katharine C. Lee, and the counsel and advice of the museum's communications director, Michael Smith.

In the process of preparing this book for publication, the professional services of many firms and individuals deserve special note. Among these, the author wishes to thank Mr. Richard Vanderpump for allowing us to reproduce the view of Rundell's old house on Ludgate Hill. The book's project manager wishes to extend sincerest thanks to Kathleen Schrader, Associate Curator of European Sculpture, Decorative Arts, and Prints, for her capable assistance and astute advice throughout the course of this project, and to her research assistant, Miss Lee Anne Hurt, for her steadfast and agile diplomacy in locating and securing even the most obscure images for comparative illustrations. The author's excellent text was further refined and polished through careful editing and proofreading by Emily Salmon, with supplemental verification of data by historian John Salmon and the relentless pursuit of bibliographical lacunae by museum library assistant Sarah Falls, and Mary Dessypris, services and outreach librarian at the Library of Virginia. The exquisite photographs of the silver objects featured in this book reveal the exacting eye of Katherine Wetzel, assisted in the studio by registrar Karen Daly and art handlers Roy Thompson and Randy Wilkinson, along with the creative efforts of faux-finisher John Balasa, all under the able coordination of photography office manager Susie Rock and Photography lab manager Denise Lewis. Under the guiding eye and graphic expertise of Sarah Lavicka, Kenny Kane combined his visual acuity and electronic imaging skills to bind pictures and text into a pleasing and compatible whole, while Sara Johnson-Ward added an invaluable measure of thoughtful book-packaging research and expertise.

Others whose cooperation and assistance have been invaluable to this publishing project include: Athlone Press, London; Bridgeman Art Library International, Ltd., London; The British Museum, London; Geremy Butler Photography, London; The Sterling & Francine Clark Art Institute, Williamstown, Massachusetts; Lady Willoughby de Eresby; The Guildhall Library, London: Jeremy Smith, Librarian; Alan and Simone Hartman; Christopher Hartop, Director of Special Departments & Executive Vice President, Christie's, New York; The Huntington Library, Art Collections, and Botanical Gardens, San Marino, California: Laura Daroca, Administrative Assistant, Art Collections; Sotheby's, London: Sue Daly, Picture Librarian; Mariuccia Sprenger, Switzerland; The National Portrait Gallery, London; Victoria and Albert Museum, London: Philippa Glanville, Curator, Metalwork, Silver, & Jewellery, Anne Eatwell, Assistant Curator, and Nick Wise, Picture Library; The Virginia Historical Society, Richmond; Westminster City Archives.

Introduction

Studying Silver in Context: By Its Use and As a Trade

There are two aspects to the history of old silver, particularly that of England, that have preoccupied scholars over the past forty years or so. One relates to its function at different levels in society, particularly the upper classes; the other concerns the structure of the goldsmiths' trade itself, its factories and workshops and the interrelation between the actual makers and retailers and their clientele. In fact, research in this area has been in progress for a hundred and fifty years, and by half a century ago it was widely believed that most of the fundamental points had been sufficiently well explored. But new inquiries, including groundbreaking studies of the trade as it was around the time of the Great Exhibition of 1851 and later,[12] have led to a much more thorough, if somewhat less overconfident, reassessment of the entire subject. In short, it is now recognized that conclusions must be drawn carefully because there is much more waiting to be discovered. Those of us who are involved in the field pursue our interests in many different ways, and there are at least three small but highly motivated academic societies in the English-speaking world devoted to the history of silver.[13] They each provide a valuable forum for discussion and the interchange of ideas.

From those ideas spring lectures, articles, books, and exhibitions that in turn stimulate yet more research and understanding. One such exhibition, *A King's Feast*, dealt specifically with the problem of how silver was used.[14] Inevitably, its bias was toward formal dinner plate, and it featured tables set as closely as possible to the way they might have appeared in the eighteenth century. With artificial fruit and other decorations, the effect was both gorgeous and instructive. Similar displays in museums and English country houses repeat the effort, some with re-creations of room interiors. Knole, one of the largest mansions in Britain, has the advantage of being equipped with a superb collection of silver—wall sconces, furniture, and the like—that has been there since the seventeenth century. (The house, located near Sevenoaks, dates from 1456 and was enlarged in 1603.)

Another dazzling display that shows objects as they would have been used is to be found at the Royal Pavilion, Brighton, on England's south coast. The Banqueting Room is replete with an extensive early-nineteenth-century service of silver-gilt from the royal goldsmiths, Rundell, Bridge & Rundell. Although not original to the Pavilion, it is certainly contemporaneous and similar to what had been there in the days when George IV used the house as his seaside villa. Of course, these are static displays; missing are burning candles in the candelabra, the reflection of diners' faces in the gleaming surfaces of sumptuous vases and wine coolers, and the ebb and flow of conversation as each new course is served.

It is unfortunate that few of us have the opportunity to dine at, say, Goldsmiths' Hall in London, where the tables are always resplendent with such pieces. But a fair idea of this type of plate actually in use has been given by a handful of modern film directors, to whom we owe a debt of gratitude for their achievements in this very problematic area. In Stanley Kubrick's 1975 film version of *Barry Lyndon*, for instance, the tale of a fictitious eighteenth-century adventurer, we find the actors dressed in the original clothes of the period and in one scene—a dramatic card game—the candles do indeed shine in silver candlesticks,[15] the sole source of light for the take. With lenses specially made by Zeiss to help catch that elusive atmosphere, Kubrick strove to convey what it must have been like to be with such people in such a room so long ago.

A similar attempt was made in another film, the 1984 *Greystoke: The Legend of Tarzan*, when the director Hugh Hudson and his crew filmed a dinner party in progress in the country seat of the sixth earl of Greystoke, an old-fashioned landed aristocrat played by the late Ralph Richardson. Set in late Victorian England, the scene captured something of the formality of such an occasion, and it is of relevance to mention it here because the table was graced with many real articles of silver-gilt of the costliest sort, actually made a little before 1830 by Rundell, Bridge & Rundell. This firm's silver-gilt punch set of 1820, now in the Gans Collection [see page 42], is a piece that might well have been on that very table.[16]

The First Collectors and Researchers

While there were a few collectors of old English silver as early as the middle of the eighteenth century, serious research was not begun until the early 1850s.[17] Before that time a proper understanding of the subject was hampered by an almost total lack of knowledge about hallmarks and the procedures for assaying gold and silver laid down by various Acts of Parliament. The first of these acts was passed in 1300, and the administrators of the British system today can justly claim that it is the oldest form of consumer protection in the world.[18]

Collectors know, just as they have always known, that English hallmarks include a guarantee of the fineness of the gold or silver used in any piece so struck. What they have not always known, however, is that the hallmarks usually include a date letter (a letter keyed to a particular year of manufacture) and are in most cases accompanied by a so-called maker's mark (usually the maker's initials). In earlier times the latter was also called a workman's, owner's, or name mark, just as now it is referred to as a sponsor's mark. Therefore, Horace Walpole (1717–1797), an early collector, could not have been expected to know the date of manufacture of three silver-gilt Apostle spoons that he had been given in 1773. He understood that they were old, of course, partly because the type by then had been obsolete for a century, and partly because he had almost certainly read Thomas Percy's edited version of *The Household Book of the Earl of Northumberland in 1512*, published a few years earlier in 1768. Here for the first time the text of an original manuscript of household accounts was made available for general scrutiny, wherein spoons and other articles of plate were listed and described. Walpole and others like him were probably not worried about the exact age of their curious, out-of-date pieces of silver and other treasures, but they did want to know that they were actually old. Sophie v. la Roche, visiting London from abroad in 1786, went to a silver shop where the owner explained to her that "antique, well-preserved pieces . . . often find a purchaser more readily than the modern. This," she was told, "is because the English are fond of constructing and decorating whole portions of their country houses, or at least one apartment, in old Gothic style, and are glad to purchase any accessories dating from the same or a similar period."[19] At the time, "Gothic" in this context simply meant "old," a disparaging reference to something that could not be linked with the great arts of antiquity: those of ancient Greece and Rome.

This love of the "old" still prevailed in 1842 when the contents of Walpole's house at Strawberry Hill outside London were auctioned. The catalogue described a certain "SPENDID OLD CHASED SILVER CENTRE VASE" as "elaborately and powerfully worked in alto relievo with matted grounds, the subjects representing the RAPE OF THE SABINES, . . . a truly remarkable and fine specimen of the early art of chasing, and for which the ancients [*sic*] are so justly celebrated."[20] Clearly the age of the piece was a mystery; more recent research has revealed it to have been purchased by Walpole as part of a set with two beakers at Lady Craven's sale in 1770. From the hallmarks it is now possible to determine that they were made in London in 1674, and that the "SPENDID OLD CHASED SILVER CENTRE VASE" is none other than a ginger jar, somewhat similar in form to the Gans example from Anthony Nelme mentioned earlier.

In most instances this confusion over dating English silver was about to be dispelled. In 1850 a Welsh antiquary named Octavius Morgan (1803–1888), whose wide-ranging interests probably led him from looking at old silver-cased watches to actual articles of silver, turned his attention to hallmarks. Within a year he delivered at a meeting of the

Archaeological Institute "some interesting remarks upon the assay and year marks used by goldsmiths in England," telling his audience that "he had been able to carry back the latter to a much more distant period than was comprised in the lists of the Goldsmiths' Company, thus affording the means of precisely ascertaining the date of fabrication of ancient English plate."[21] Morgan went on to publish his findings in print in 1853,[22] which opened the way for a revolution in silver studies.

While Morgan came from a privileged background—his father was Sir Charles Morgan, second baronet of Tredegar Park—his most important rival in the field of old silver was no more than a shopkeeper's son. This was William Chaffers (1811–1892), an energetic member of the trade who had been brought up in the family pawnbroking firm in the City of London. Dismissed by contemporaries in academic circles as a "professional antiquary," Chaffers is nevertheless a key figure whose *Gilda Aurifabrorum*, published in 1883, was the first book to examine the London goldsmiths' trade from within and from the point of view of business history rather than of trends in design and craftsmanship.

Some years before, in 1863, Chaffers had brought out *Hall Marks on Gold and Silver Plate*, wherein he gave a list of silver pieces, their dates, and the names of their present owners. Most of the objects he cited had been included the year before in the Special Loan Exhibition at South Kensington, in particular the great silver-gilt ewer and dish from the Goldsmiths' Company, mentioned above. Chaffers attributed these two items to "Paul Lemere," undoubtedly a misspelling of the name Paul de Lamerie. No other pieces in his treatise received attribution, but two years later in 1865 *Hall Marks on Gold and Silver Plate* was issued in a second edition, which was virtually identical to the first except that the Goldsmiths' Company's ewer and dish together with other pieces bearing the "PL" maker's mark had been properly identified as the work of Paul de Lamerie. The new information appeared in a footnote, proving that the author had actually taken the trouble to examine the original source:

> The first entry of Paul de Lamerie in the mark book of the Goldsmiths' Hall occurs in 1712 [actually 1713], when he resided at the Golden Ball in Windmill Street, in the Haymarket. In 1739 he removed to Garard or Gerard [Gerrard] Street, Soho.[23]

It was from this point that the study of old English silver—together with its marks and the silversmiths who produced it—became well organized.[24] Haphazard guesswork increasingly became a thing of the past as new books and magazine articles appeared and exhibitions were mounted. At least one retail goldsmith, however, Edward J. Watherston, became irritated by the new fad that manifested itself following these developments: "We are martyrs to the old plate craze—old Hall-marks," he complained. "There are people who will give any price for antique plate, however ugly, and however badly made." These remarks, made in 1893, coincided precisely with the period when the names of three London silversmiths—Paul de Lamerie, Paul Storr, and Hester Bateman—began to dominate among those of many others that by then had been identified. Indeed, these three were the first English silversmiths whose memories were to be honored by books about their lives and work: P. A. S. Phillips, *Paul de Lamerie, Citizen and Goldsmith of London: A Study of His Life and Work, A.D. 1688–1751* (London, 1935); N. M. Penzer, *Paul*

Storr: The Last of the Goldsmiths (London, 1954); and David S. Shure, *Hester Bateman: Queen of English Silversmiths* (London, 1959).

It is ironic that the authors of these three books, the first two of which are valuable standards in their class and all three the result of much toil and research, should have aimed to present their subjects as artists-craftspeople rather than as what they really were: successful businesspeople. Of course, it should not be forgotten that information about the personal lives of individuals living so long ago was, and is, often hard or impossible to recover. That having been said, however, Phillips, Penzer, and Shure to a greater or lesser extent did idealize the role of their protagonists. Perhaps the reason for this arose from the popular misconception as to the purpose of the so-called maker's mark. It was not, as many believe, an artist's or a craftsman's signature. Instead it served the function of confirming to the Assay Office officials that the person in whose name the mark had been previously registered was the individual who took responsibility for any shortcomings should a piece fail to come up to standard. William Chaffers, that despised "professional antiquary," had already explained the situation nicely in 1883 when he told his readers that

> There are necessarily in every piece of decorative plate three parties to whom the credit of production must be ascribed, viz. the artist who designs it, the plate-worker [i.e., silversmith] who makes it, and the goldsmith [i.e., the retailer] who sells it and becomes the publisher. In very few instances does the name of the artist transpire; the plate-worker is compelled by law to place the initials of his name on his work, being responsible alone to the Goldsmiths' Company for its quality. The goldsmith rarely places his name, but reaps the benefit by its sale and establishes his reputation thereby. He is the patron of the work, remunerates the artist for the design according to its merit, and pays the plate-worker for its production, and it is his risk whether he obtains a remunerative price for his outlay; his name and connexion [*sic*] give him the opportunity of an advantageous sale, which neither the artist nor the plate-worker may possess. Hence all three conduce to a successful result attained in its appreciation by an enlightened purchaser.[25]

Unfortunately, in the avalanche of information that became available over the succeeding fifty or sixty years, these wise words were forgotten or ignored. Too much emphasis began to be placed upon makers' marks, and writers, collectors, antique dealers, and auctioneers soon created extravagant claims for this or that "maker." It was inevitable, by virtue of the great numbers of pieces of silver that bear their marks, and in the cases of the first two because of the often high quality involved, that Paul de Lamerie, Paul Storr, and Hester Bateman should have become such popular names in the world of English antique silver.

On the Work of Hester Bateman

While the writers of the books on the three most popular silversmiths—Paul de Lamerie, Paul Storr, and Hester Bateman— began their investigations upon an erroneous hypothesis, their work was not entirely invalidated by the findings of later researchers. It was more a matter of adjusting the emphasis of their conclusions than it was in contradicting their findings, although in a review of *Hester Bateman* that appeared shortly after the book itself, Arthur Grimwade, then director of Christie's Silver Department and later author of a book on London goldsmiths from 1697 to 1837, made the situation clear.

In response to David Shure's enthusiasm for the female members of the Bateman family, notably Hester's daughter-in-law Ann (widow of Jonathan, whose joint mark with Peter was entered in 1791) whom Shure describes as "a superb craftswoman," Grimwade asks, "how does he [Mr. Shure] know? Surely the appearance of her initials in the [maker's] mark is merely the recognition of her financial share in the business after her husband's death and we are not entitled to assume more without direct evidence."[26]

My own work on Hester Bateman and the Bateman family of silversmiths was published in 1977[27] following the discovery of some insurance records and a plan of the company's manufactory, which lay in an area a little over half a mile northeast of St. Paul's Cathedral (FIGURE 2A). These documents, together with surviving silver bearing the Batemans' marks, proved fairly convincingly that for much of its existence the Bateman firm not only was geared to a high level of production—far more than two or three individuals could ever have managed by themselves—but also was a supplier of sheet silver to other workshops. The plan, dated 1802, confirmed this latter fact by describing the business as "Goldsmiths & Metal flatters," and recording that it had a steam engine and a horse mill together with a "flatting Mill." Hester Bateman herself retired in 1790 at the age of about eighty-two. Clearly, the latter-day notion of her having been an actual working silversmith (as was suggested in a recent romantic novel), is very fanciful indeed.[28]

Researching Paul de Lamerie

With regard to Paul de Lamerie, there is plenty of evidence to suggest that he was an actual working silversmith for part of his career and became a master of his craft as well as a businessman and respected member of the community. Only death at the age of sixty-three on 1 August 1751 robbed him of becoming Prime Warden of the Goldsmiths' Company. The *London Morning Penny Post* described him afterwards as "an eminent Silver Worker," and the *London Evening Post* as a man who "was particularly famous in making fine ornamental Plate, [and he] has been very instrumental in bringing that Branch of Trade to the Perfection it is now in."[29]

Heroic efforts have been made to add more detail to what P. A. S. Phillips published about de Lamerie's life, particularly in 1990 at the time of the exhibition of work bearing his mark.[30] He remains a somewhat elusive character, however, and the question still remains as to how much of the silver bearing his mark he actually made or had a hand in making himself. We will probably never know. Besides, as Helen Clifford has shown,[31] a business as complex as de Lamerie's must have required an agile leadership aided by many hands with many talents to function successfully. James Shruder, whose fine work is spectacularly represented in the Gans Collection,[32] presumably did not have such business acumen, for he was declared bankrupt in June 1749. So it is of especial interest to find him a signatory to de Lamerie's will, signed in May 1751, from which it has been suggested that he worked in some skilled capacity, possibly as a modeler, during the years immediately preceding de Lamerie's death.

In the Workshops of Paul Storr

As we have seen, by 1739 Paul de Lamerie had quit Windmill Street, from where he had entered his first mark in 1713, and had moved to Garard (properly Gerrard) Street.[33] Both these addresses were in London's Soho directly to the north of Leicester Fields (later Square) (FIGURE 4). Like Clerkenwell, a little to the north of the City of London (FIGURE 3), this area has long been identified with manufacturing workshops, many connected with the gold, silver, jewelry, and allied trades. An examination of either of these districts from the second quarter of the eighteenth century until relatively recently would reveal the presence of many gold- and silversmiths whose names are familiar to collectors of antique silver through the survival of work bearing their marks. One of these, active for many years in Soho, was Paul Storr (1770–1844), a man connected with a number of fine objects in the Gans Collection. Indeed, among Mrs. Gans's own personal favorites at the Virginia Museum of Fine Arts is the beautiful Storr silver figure of Hebe of 1829–30, featured in Joseph Bliss's first volume on the Gans Collection.

Paul Storr deserves our special attention because, with few exceptions,[34] we learn more about the structure of the London goldsmiths' trade from the details surrounding his career than almost any other individual who entered a maker's mark at Goldsmiths' Hall. In planning his book about Storr, N. M. Penzer rightly identified him as a pivotal figure in the business at the turn of the eighteenth century. It was not until 1966, however, with the publication of Shirley Bury's articles "The Lengthening Shadow of Rundell's" in the magazine *Connoisseur*, that a true assessment of his position was fully understood.[35]

As with de Lamerie, we know almost nothing about Paul Storr the man, his personal life and character. Nonetheless, some facts about his early life and career are available. Baptized in the parish of St. Marylebone (north of Oxford Street, London) on 28 October 1770, he was one of several children of Thomas Storr, a silver chaser who, by the time Paul was eighteen, had changed his calling to that of a victualler.[36] Paul may himself have trained as a silver chaser, but in 1784 he was apprenticed to William Rock of Westminster, another victualler. After serving his time, Paul Storr became free of the Vintners' Company in 1791 and went into business as a silversmith with William Frisbee but quickly moved on to premises in Church Street, Soho (FIGURE 4B), that had been occupied by a Swedish-born silversmith called Andrew Fogelberg. Although the nature of Storr's and Fogelberg's relationship is not fully understood, it is possible that the latter became a sleeping partner in the business; certainly the two men knew each other for many years afterward, since Fogelberg's widow, Susanna, sold Paul Storr Fogelberg's house up on the fresh heights of Hampstead, far away from crowded Soho, after Fogelberg died sometime in 1814 or 1815.

By 1796 Storr had moved his workshops to 20 Air Street, Piccadilly, at the southern edge of Soho. It was here that Thomas Pitts, a successful manufacturing silversmith specializing in epergnes, soup tureens, and other high-quality goods, had had his workshops. In fact, it may be that Storr took over Pitts's business, although this is far from certain. Over the next decade Storr managed to turn his own business into one of the most important of its kind in London, supplying high-quality standard work and special orders to retailers. But before we look at the next phase in his business life, which began in 1807, a glance at the London trade from a shopper's point of view would be helpful.

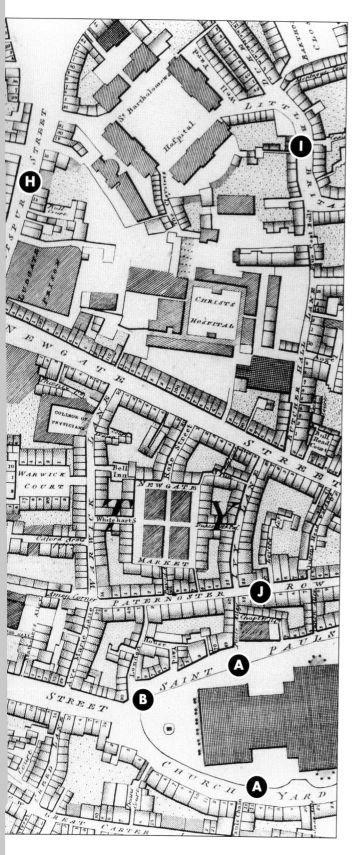

FIGURE 2. *A section of Horwood's map of London, 1799,* showing part of **Fleet Street**, as well as **Ludgate Hill** and **Ludgate Street** (now Ludgate Hill) intersected by **Bridge Street** and the **Fleet Market** (formerly the Fleet River, now Farringdon Road), with **St. Paul's Cathedral** and **St. Paul's Churchyard** to the east. (*Courtesy Guildhall Library, London. Photo by Geremy Butler Photography*)

A.) *St. Paul's Churchyard*, a place of many fashionable shops during the eighteenth century, was the original location of the business, then owned by Henry Hurt, that later became Rundell, Bridge & Rundell. Hurt moved to 32 Ludgate Hill in 1745.

B.) *Phillips Garden, a substantial retail silversmith,* (see Figure 5) was established in premises on the north side of St. Paul's Churchyard from 1739 until his bankruptcy in 1762.

C.) *The Golden Salmon, the retail premises of Rundell & Bridge* (later Rundell, Bridge & Rundell) was at (1) 32 Ludgate Hill, the fifth house along to the west of the corner of Old Bailey. Between it and (2) 33 Ludgate Hill (at some time occupied by Joseph Routledge, retail jeweler), ran Sword and Buckler Court (changed in 1824 to Horse Shoe Court) where Rundell's had various workshops including (from about 1835) those of the manufacturing silversmiths John Tapley & Co.

D.) Elsewhere on the map we find *in Fleet Street the house on the south side to the extreme west (No. 61) the premises of the retail goldsmiths and jewelers Whipham & North.* This business was established by Thomas Whipham Jr., a working silversmith who moved there in 1775 to become a retailer. Previously he had been at Amen Corner, Ave Maria Lane (sometimes Ave Marie Lane) off Ludgate Street to the east, where he had succeeded to the firm established about 1680 by the working silversmith Anthony Nelme.

E.) *Joseph Brasbridge's shop was at No. 98 Fleet Street* on the south side, at the corner of Bride Lane next to St. Bride's Church.

F.) *The premises of James Cox, retail goldsmith and jeweler, were at 103 Shoe Lane*, running north out of Fleet Street, parallel to Fleet Market. He was declared bankrupt in 1778.

G.) *Cock Lane off Snow Hill* to the north, where Paul Storr was briefly in partnership with William Frisbee in 1792.

H.) *Giltspur Street, running north out of Old Bailey*, where the silver spoon- and fork-maker Richard Crossley was established between about 1783 and 1798.

I.) *Little Britain to the extreme northeast*, where the working silversmith turned banker and refiner Robert Albion Cox was in business.

J.) *Paternoster Row, immediately north of St. Paul's*, where the considerable silver spoon- and fork-makers Chawner's had their business for most of the second half of the eighteenth century.

K.) Another notable firm in this area was *Green & Ward, retail goldsmiths and jewelers, at 1 Ludgate Street* on the south side opposite the church of St. Martin's. Established there since 1798, Green's moved west in 1829 to 20 Cockspur Street, Pall Mall.

Bunhill Row, where Hester Bateman and her family were situated, is a little to the northeast beyond the area covered by this map.

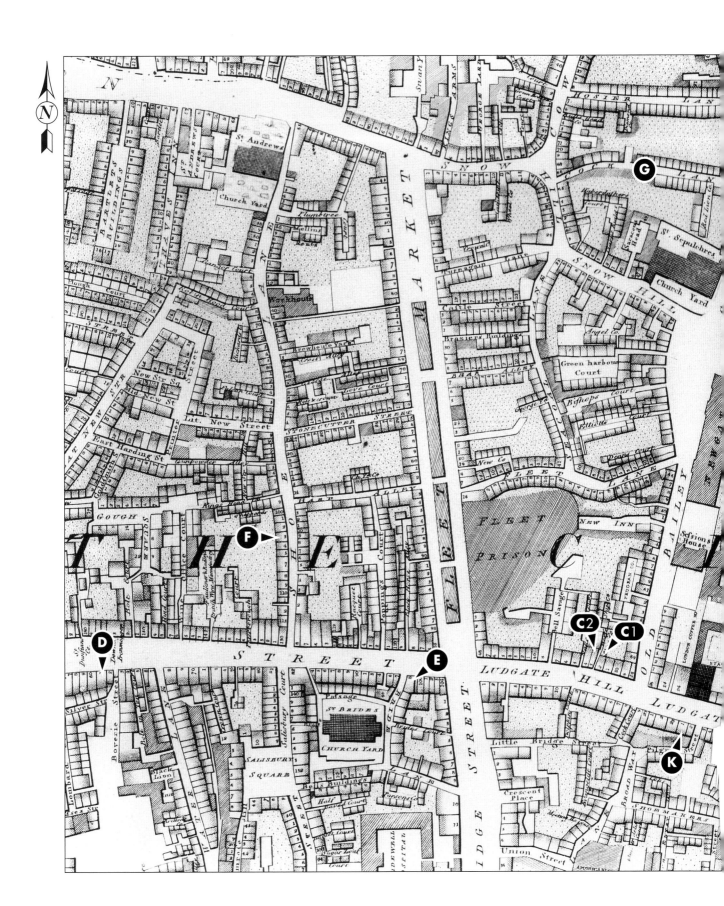

The Maps

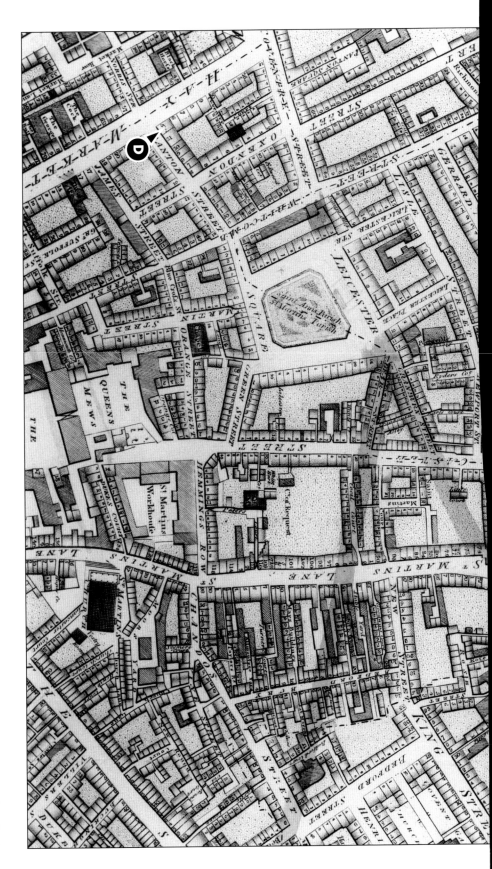

FIGURE 4. *A section of Horwood's map of London, 1807, with Leicester Square* (formerly Fields) a little below the center. *(Courtesy Guildhall Library, London. Photo by Geremy Butler Photography)*

A.) *Gerrard Street (now the center of London's Chinatown), where Paul de Lamerie lived and worked* in a house (now No. 40) is believed to be the general location of Lamerie's house. Exact site uncertain due to subsequent rebuilding.

B.) *Church Street ran parallel to Gerrard Street* two streets to the north and opposite St. Anne's Church, Soho. **Paul Storr succeeded the silversmith Andrew Fogelberg at No. 30** on the north side, staying there for a little under three years.

C.) *Storr subsequently occupied Nos. 53 and 54 Dean Street* (renumbered 75 and 76 in 1818) between late 1807 and the end of 1818, where he superintended Storr & Co., the silver manufactory of Rundell, Bridge & Rundell. These premises continued to be Rundell's chief silver factory until closing shortly after John Bridge's death in 1834. Afterward Rundell's factory was transferred to that of William Bateman, Hester's grandson, in Bunhill Row. For later photographs of this building, see Figures 7 and 11.

D.) *Panton Street, running from the southwest corner of Leicester Square to the Hay Market*, was the *location of R. & S. Garrard & Co.* and its predecessors from 1735 to 1911. For a photograph of the corner building, No. 25 Hay Market, see Figure 1.

E.) *Seven Dials, the area where seven streets meet at the extreme northeast of the map*, was long known for the number of its jewelers' and goldsmiths' workshops.

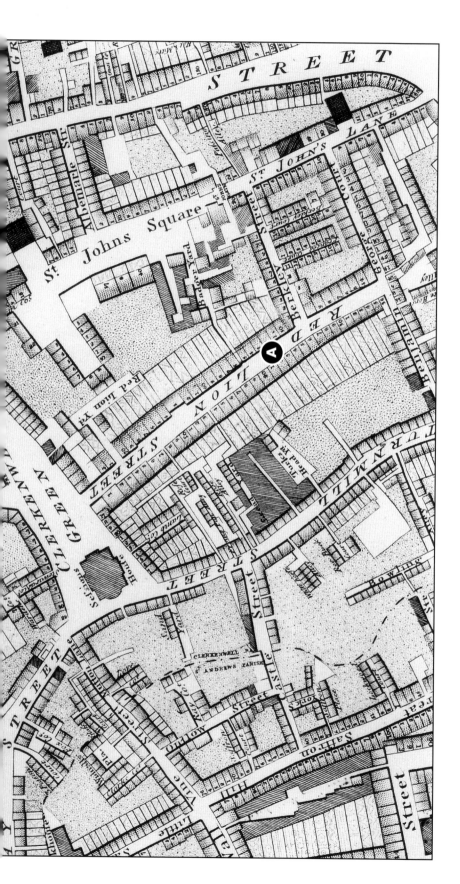

FIGURE 3. A section of Horwood's map of London, 1799, showing Clerkenwell Green a little below the center. (Courtesy Guildhall Library, London. Photo by Jeremy Butler Photography)

During the eighteenth and nineteenth centuries and for much of the twentieth century this was **an area that had abundant signs of the goldsmiths' trade** in all its manufacturing and wholesale branches, from largeworking silversmiths and chasers, to jewelers and gold and silver watchcase-makers. It was also the center of London's watch-manufacturing trade. At the present time (1999) Hatton Garden and Cross Street at the extreme southwest of the map are considered to be the heart of London's wholesale district for jewelry, precious stones, and works in gold and silver.

A.) Red Lion Street (now Britton Street), Clerkenwell, running southeast out of Clerkenwell Green, **boasted several manufacturing silversmiths.** One was John Houle, formerly apprenticed to Paul Storr as a chaser, who established his business at 24 Red Lion Street about 1811. Another was Jonathan Hayne, who went into partnership with Thomas Wallis about 1810 at No. 16 Red Lion Street; this firm, which before 1842 was equipped with steam engines, was probably begun by another Thomas Wallis in the late 1750s in Little Britain (see Figure 21).

B.) Clerkenwell Close, running north out of Clerkenwell Green and skirting St. James's Churchyard, **was another thoroughfare once known for its working silversmiths.** George Burrows, a silver smallworker and buckle maker, was there in the 1770s and 1780s. Others in the area were Francis Butty, Nicholas Dumee, Lewis Herne, and William Holmes, all of whom appear to have been connected in business during the second half of the eighteenth century either in Clerkenwell Close itself or in nearby Clerkenwell Green.

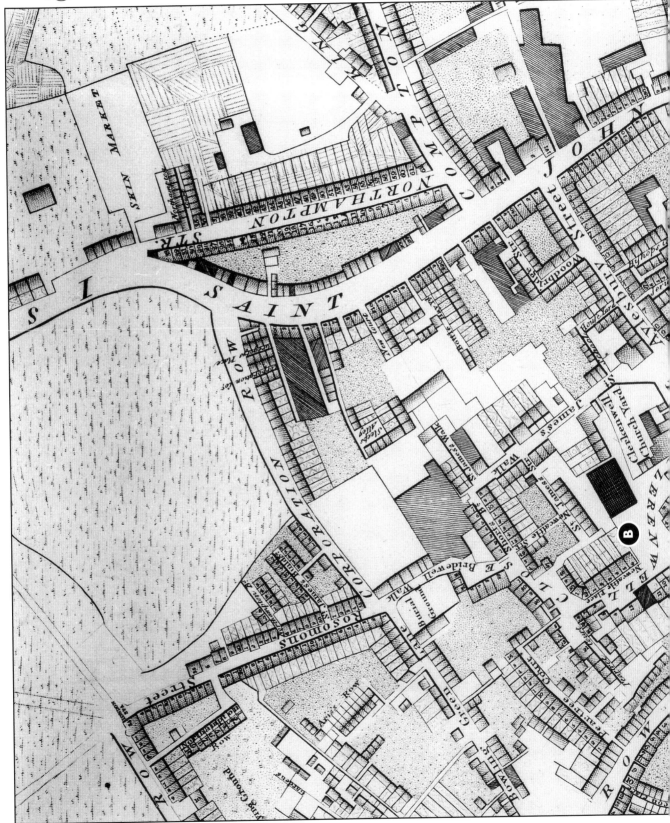

9

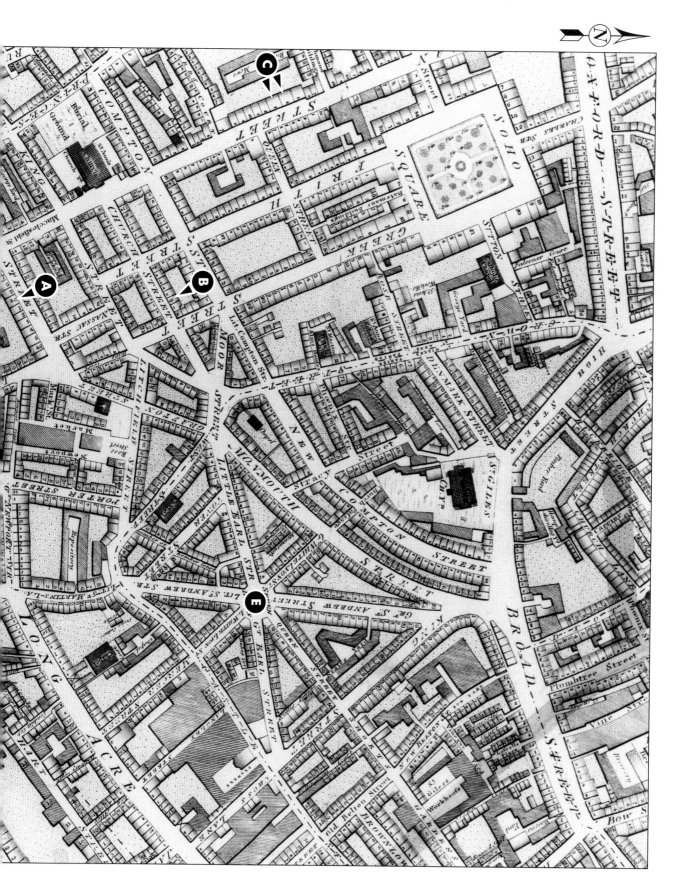

The London Retail Goldsmiths' Trade, 1690s to 1860s

The locations of two retail concerns that around 1800 called upon the special skills of Paul Storr's workshops—the watchmakers Vulliamy[37] & Sons and the royal goldsmiths and jewelers Rundell & Bridge—were at Pall Mall and Ludgate Hill respectively (FIGURE 2). The first was in the City of Westminster on the west side of central London and the second was in the City of London near St. Paul's Cathedral to the east (FIGURE 2C). Between these two places were a series of streets—Pall Mall to the Strand via Charing Cross,[38] and Fleet Street to Ludgate Hill—that ran more or less in a gentle curve slightly north of a bend in the River Thames. Where Ludgate Hill ended, so began Ludgate Street, which opened into St. Paul's Churchyard (FIGURE 2A). Behind the cathedral lay Cheapside and the other thoroughfares about which, in spite of the Great Fire of 1666, a Jacobean Londoner would have had little difficulty in finding his way.

At the close of the eighteenth century, good retail establishments were in many other parts of London, too, especially in the vicinity of Bond Street and Piccadilly, Leicester Fields (later Square), and the Hay Market (FIGURE 4), and farther north along Oxford Street and Holborn. But some of the best shops for every type of luxury goods—from jewelry and other goods made with precious metals to textiles and provisions—had long been in the streets leading to St. Paul's. Even today (in 1999) there survives in the Strand and Fleet Street two old businesses—a news agent established in 1700 and a tea merchant (Twining's) begun about ten years later—along with various public houses and private banks of the period.

In spite of the vicissitudes of trade and periodic financial crises, there are many stories of success to be found in the goldsmiths' trade, where shopkeepers retired on comfortable fortunes to country houses. One was James Neild (1744–1814), a native of Cheshire, who went to London where he was apprenticed to Thomas Heming (FIGURE 6), goldsmith to George III. Inheriting a legacy in 1770, Neild was able to open his own business in fashionable St. James's Street, which ran between Piccadilly and Pall Mall. He quit business a little over twenty years later with enough to leave his son a considerable estate.[39] Neild's private passion, however, is of rather more interest than his success, for it concerned those less lucky than he had been, a class of person unhappily all too familiar to Londoners of the eighteenth and early nineteenth centuries: bankrupts and insolvents. Having in his youth visited an impecunious fellow apprentice in the King's Bench Prison, Neild became determined to help others like him who were obliged to rely on charity for their very existence, and who often languished in gaol for want of a little cash with which to buy their freedom. It was a pernicious system that Parliament did not really address satisfactorily until the early 1830s. Knowing that official assistance—in the form of various Bankruptcy Acts—was available only to individuals who had failed in more or less substantial businesses, Neild wasted no time in organizing The Society for the Discharge and Relief of Persons Imprisoned for Small Debts. Thirty years after its establishment in 1772, the Society was able to report that with donations of a little over £49,000 it had released 19,063 debtors and their 11,399 wives and 32,871 children, a total of 63,333 persons. Inevitably, a number of these individuals were working and retail gold- and silversmiths, as well as jewelers and their families.

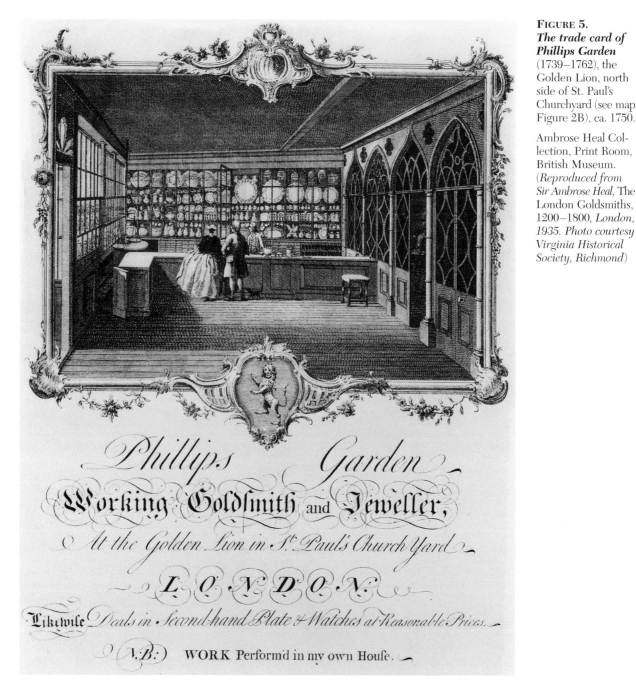

FIGURE 5.
The trade card of
Phillips Garden
(1739–1762), the
Golden Lion, north
side of St. Paul's
Churchyard (see map
Figure 2B), ca. 1750.

Ambrose Heal Col-
lection, Print Room,
British Museum.
(*Reproduced from*
Sir Ambrose Heal, The
London Goldsmiths,
1200–1800, *London,*
1935. Photo courtesy
Virginia Historical
Society, Richmond)

Ironically, it is from the stories of these failures that much information about the trade and its members has survived. Joseph Brasbridge (1743–1832), a retail silversmith with a shop in Fleet Street, was one. Having emerged from bankruptcy and reestablished himself through the help of friends, he published an autobiography, *The Fruits of Experience* (1824), as a warning to others. Along the way he recorded a number of facts including rare information about the personalities of some of his trade contemporaries. One of his suppliers was Matthew Boulton of Birmingham, whose factory (built in 1764)

FIGURE 6.
The trade card of Thomas Heming, goldsmith to George III, at the King's Arms, New Bond Street, facing Clifford Street, 1765–73. Ambrose Heal Collection, Print Room, British Museum. (*Reproduced from Sir Ambrose Heal,* The London Goldsmiths, 1200–1800, *London, 1935. Photo courtesy Virginia Historical Society, Richmond*)

Heming's shop was located very near to the present Nos. 162–167 New Bond Street, a little farther north on the same side of the street. These premises have been occupied for many years by Asprey & Co. Ltd., goldsmiths, jewelers, et cetera, which on 1 September 1998 was amalgamated with the Crown Jewellers Garrard & Co. Ltd. of Regent Street to form a company styled Asprey & Garrard.

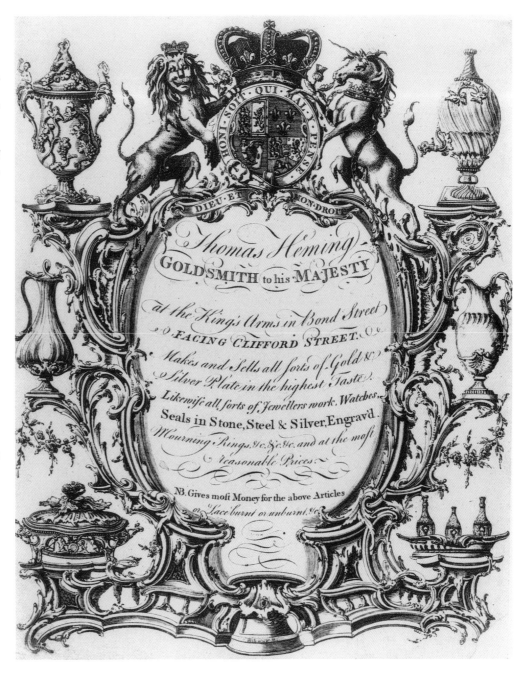

produced wares in silver and Sheffield plate with which he hoped to undercut the London manufacturers; in this he was very successful, and he also had a brisk provincial and overseas trade. Brasbridge was especially pleased to acknowledge success when the subject had had lowly beginnings, as in the case of Richard Crossley, who rose to become head of a prolific firm of silver spoon- and fork-makers: "He came originally to London as a boy and was employed by Chawner, the spoon-maker in Paternoster-row, to carry charcoal to his men; hence he was known by the name of Charcoal Dick but being a smart lad and writing a good hand, he was soon promoted to a place in the counting house."[40]

A Study in Failure: The Retail Goldsmith Dru Drury

In fact, many practical gold- and silversmiths—Paul de Lamerie was probably one and Paul Storr another—attained prominence by becoming entrepreneurs. In the case of Dru Drury (1725–1803), however, much of his story has come down to us chiefly because of the unfortunate circumstances of his failure in business as a retail goldsmith. The extraordinary point about him is that not only has his bankruptcy file survived,[41] but so has his 1761–83 letter-book, being copies of his "out" correspondence, mostly written by himself.[42] The letters tell of a tenderhearted family man, zealous but gullible in business matters. He was also fond of writing; as he once confided to a friend, "when I get a pen in my hand I know no end to scribbling."

At the time of Drury's first-surviving letters, in the early 1760s, he was engaged in the manufacture of silver handles for knives and forks with steel blades and prongs. The business, in Wood Street, City of London, was begun by his father. In December 1763 we find Drury in secret negotiations with James Bedford, a cutler in Birmingham, to supply steel blades: "I apprehend you are acquainted," he wrote, "that th[ere] is but one person in London who [makes them] & as such supplys ye whole Town for [which] reason perhaps if he knows that I ever wrote to you on ye Subject that I now do he may refuse to let me have any blades at any price."

Five years or so later, Drury was in correspondence with Robotham & Sykes of Sheffield, from which it is clear that he was ordering silver handles that he intended to have hallmarked in London.[43] Drury was also in touch with a Sheffield-based engraver named Thomas Billam about patterned steel dies that he wished the latter to make. On 18 December 1770 Drury wrote, "I . . . forbore telling you my reason for desiring you to be secret in doing the Dies. The reason was because I was about applying for a Patent for making Hafts [i.e., handles] with concave dies & therefore did not choose to let it be known 'till I had produced it wch. I have not got. . . . I should mention that this privilege I have produced in consequence of my considering myself in conjunction with my late Father as ye first inventors, having used them a great many years ago."

Drury's letters are eloquent about his attempts at improvement, but also tell of a sinister development. To a friend in 1770 he wrote: "My business [which] was a very good one is starting to decay very fast, occasioned by the Sheffield people having entered into it, who always reduce every trade they engage in to such a degree that nobody in London can get a living by it." A paradoxical statement from one who had actually *encouraged* the Sheffield people! Ready cash, or rather the lack of it, was another of Drury's problems. As early as 1768 he had told Nagle, a goldsmith in the west of England at Bristol, that money "is very scarce in London at the moment." Then in 1769 we find him begging Lewis Pantin, a goldsmith, jeweler, and toyman[44] at the sign of the Crown and Sceptres in Fleet Street, for settlement, at least in part, for an account that had been outstanding for two and a half years. To emphasize the point, Drury explained that he was in such want of funds "that my business at present stands still. . . . I have a great deal of work bespoke without any money to finish it with."

Of course, unpaid bills and the constant promises of customers to honor their obligations were then a major feature of commercial life. Occasionally even the good-natured Drury's patience was stretched; Roger Simkinson, another goldsmith in Fleet Street, received from him in 1770 the following furious but ultimately ineffectual note: "The number of

breaches of promise that you have made me altho given in ye most solemn manner oblige me to consider your behaviour as perfectly trifling."

Early in 1771, Drury wrote to a Sheffield supplier, "I am now engag'd in partnership with Mr. Jefferys Goldsmith to [His] Majesty at ye Corner of Villiers Street [and] York buildings, & as that business is very different from my own [I] shall have no occasion for those blades." Drury also informed Billam of his new situation, in consequence of which, he said, he had disposed of his old firm to William Abdy.[45] The remaining dies now belonged to the latter, "by Virtue of his agreement to purchase my tools & business." This is an interesting fact in itself, besides which Abdy is thought to have employed at least one workman, Richard Eglinton, from Sheffield in the late 1760s, and may also have had business correspondents in that town.

Drury was foolish to think that all his difficulties would go away by changing the course of his career from a specialist manufacturing silversmith to a retail goldsmith and jeweler. That he hoped to succeed by entering into an agreement with one as canny as Nathaniel Jefferys can leave no other impression than that he was pitifully naive. In the event, he fell victim to yet other sharks patrolling those dangerous waters.

That same year (1771), when he was forty-six, Drury moved to the shop on the corner of Villiers Street and the Strand. At first he was very happy with the progress of business, although what Jefferys made of his partner's perhaps overeager contention that *Resolution & Industry* will overcome every thing" is not known. A little later, Drury explained his new position, that of a retailer, to a friend: "My hours now from Morning to Night are so fully engaged in business as to have very little time that I can employ in any amusement. . . . I told you some time ago my business was a *working Silversmith*; [when] an opportunity offered of going into partnership with Mr. Jefferys . . . , I accordingly embraced it . . . Mr. Jefferys, who is sliding out of Trade leaves the greatest part of the business (at my own desire) to me & till I can get my people so fully initiated & experienced as to be able to supply my absence I must of necessity be much confined."

Only eighteen months after Drury began his new life, however, business was all but dead. Writing to Jefferys in August 1772 to ask for a loan of £100, he confessed to feeling "a depression of Spirits that is trully extream." Drury's problem was the old one of being obliged to extend credit to too many people. He complained that by conceding to his customers' wishes he had very little money besides what was taken daily in the shop to continue the enterprise satisfactorily. Jefferys sent drafts for £100, but it was just the beginning of another decay, this time much more serious than the last. Drury was drawn ever deeper into a vortex of transactions that, ironically, appeared to help but actually hindered his business. It was a familiar predicament that his involvement with a Mrs. Phipps will demonstrate.

This lady, who had a sugar plantation in Saint Kitts and an annuity of £200, applied during 1773 to Drury for an advance. Wishing to conceal the matter from her family, she conducted negotiations through a certain Captain Crooke, and the security offered was a joint bond in both their names. Crooke assured Drury that the lady was a woman of fortune, a fact confirmed by a third party, a Mr. Price, who pressed the timid jeweler by mentioning "that if she had applied to some other persons she might have the money advanced without Hesitation." The affair was complicated by the presence of a "pair of rich Earings," apparently from Drury's stock. Indeed, it may have been for the sake of the earrings that

Mrs. Phipps wished for the advance in the first place. Like any wary agent, Crooke sought advice about these gems elsewhere, from Duval's, the King's Jeweller,[46] and from Anthony Planck, another wealthy jeweler of the day. Drury, on the other hand, was in such a quandary over laying-out the money for the advance that he wrote for advice to Nathaniel Jefferys. The latter, then taking the air at Brighton with his wife and daughters, would no doubt have delivered his reply in the knowledge that another of Mrs. Phipps's friends, a Captain Lee, was about to marry the rich young daughter of a peer. Jefferys knew the delicacy of such a situation; although he had said modestly in 1761 that he was the keeper of a toy shop,[47] he had, in fact, just been appointed cutler to George III and was familiar with the vagaries of upper-class life. Jefferys's position as an intermediary was furthermore vital to his friend, the aforementioned Matthew Boulton, in the latter's attempts to introduce his Birmingham-made buttons to the royal family.

Drury eventually sold the earrings at a profit for £600, but such a deal and its possible far-reaching consequences clearly unnerved him. Matters were still not concluded more than a year later when under the pretense of urgent prompting from Jeffreys, Drury wrote to both Mrs. Phipps and Captain Crooke asking for a settlement of their bond. Meanwhile, Drury had become enmeshed in other, more hazardous transactions that blocked his liquidity still further and led to his ultimate financial collapse.

In September 1772, Drury had written to Jefferys in apology for not being able to remit for the moment more than £20. By way of explanation he confessed that a draft of £200 he had exchanged with James Cox, a celebrated retail jeweler and supplier of expensive clocks and other mechanical devices, for promissory notes of small sums had all been returned unpaid. "Cox's non payment of these Notes has disappointed me greatly," said Drury, "the more, as happening at this dead time of the Year when little business stirs, no money circulates & workmen *will* be paid."

Drury's credit deteriorated still further over the next six years until by the autumn of 1777 his position was critical. He unburdened himself in a long letter to a Mrs. Pratt, to whom he gave "vent to a Heart almost broken with the thoughts of those happy times I once enjoyed which now like airy dreams are passed & only ye faint Ideas thereof are left behind." How much Jefferys contributed to his partner's unfortunate position is not easy to say. Perhaps a man less emotional, more cold-blooded than Drury might have over-come the ambitious requirements of their original agreement. He told Mrs. Pratt that upon joining Jeffreys the latter's debt "was liquidated & settled at £11000 [which] was to lessen by paying off every year £1000 of the Principal [which] I constantly did [un]till ye year before last but ye payment of so large a sum annually besides the Interest on the remainder was such a continual drain to me as to be more than my proffit would allow at those early periods & in short what I never could overcome & put me upon the necessity of raising money upon Notes & Bills by every way I could devise."

Poor Drury was distraught. He ended the letter to Mrs. Pratt with thoughts only for his wife and son, writing, "nor can the utmost stretch of my Philosophy prevent the tears flowing involuntarily from the misfortunes I have thus brought on them." The Bankruptcy Act was mercifully at hand and the first official moves in his rescue were made on 18 November 1777. The Commissioners' file, begun on that occasion and added to over the next nine years, contains a remarkable wealth of information, starting with a detailed list

of more than a hundred and seventy of Drury's creditors, with their names, addresses, and occupations, along with the dates of transactions, the amounts owed, and the means by which those debts had been incurred. Various other items complete the picture. Exhibit A consists of an account of Drury's stock at the time of his bankruptcy: in addition to more than three thousand ounces of silver, he had more than seventy different categories of stock ranging from snuff boxes and gorgets[48] to pocketbooks and knife-box mounts, totaling in value £6,542 8s. 10d. Exhibits B, C, D, and E relate to Drury's estate, details of bills of exchange, and the names of his own good and bad debtors. There were also various books numbered 1 to 16, perhaps Drury's daybooks and ledgers, but these almost certainly do not survive.

The presence of Robert Albion Cox, banker, refiner, and former manufacturing silversmith, as one of Drury's assignees, should come as no surprise. Without doubt one of the most important members of the trade at that time, Cox had the connections and resources to wield considerable power. Both he and Nathaniel Jeffreys were also among Drury's trade creditors, who included the following London-based manufacturing silversmiths: William Abdy; Charles Wright, a maker of coffee pots and other holloware (whose business, founded by Anthony Nelme around 1680, is still in operation as Edward Barnard & Sons); Samuel Meriton, a maker of nutmeg graters and other small wares; Burrage Davenport, a supplier of silver baskets and the like; Margaret Binley, a maker of silver wine labels; and the largeworkers[49] Walter Tweedie, Thomas Daniell, Walter Brind, George Burrows, and John Scofield. The last mentioned is chiefly known now for fine-quality candlesticks.

Drury's creditors furthermore included the formidable Ludgate Hill partnership of William Pickett and Philip Rundell, who claimed a debt of more than £1,200. The apparent simplicity of that fact, however, concealed an intricate situation. The debt had been incurred "for Goods Sold and Delivered to [the aforementioned] James Cox upon Credit of the several notes of hand hereafter mentioned . . . five promissory notes all Drawn by the Bankrupt [Drury] and Indorsed to [Pickett and Rundell], [four of them as follows:] one dated 19 June 1777 whereby he promised to pay John Obadiah Justamond o[n] order £212:10, . . . one other dated 2d. Octo 1777 whereby he promised to pay the said James Cox o[n] order £250 . . . sixty eight days after Date, one other dated 25th Oct. 1777 whereby he promised to pay the said James Cox o[n] order £250 . . . six months after date, and one other dated 28th Octr. 1777 whereby he promised to pay the said James Cox o[n] order £250 . . . six months after Date."

In this excerpt we can glimpse the far-reaching nature of Drury's activities, but they were probably not so very different from the affairs of most other eighteenth-century retail goldsmiths. His bankruptcy file is littered with such memoranda. Suffice it to say that the name of James Cox occurs many times, usually in relation to Drury's indebtedness to him or to Cox's indebtedness to yet other parties. Moreover, Cox, who himself became bankrupt in 1778, shared an assignee with Drury in the person of the ubiquitous Robert Albion Cox. It would seem, therefore, that Dru Drury's and James Cox's separate bankruptcies were inextricably bound up with one another, each dependent to some degree upon a huge debt of £7,500 owed to Drury by one of his private customers.

While Drury's modest business foundered on relatively simple money problems arising, in part, from unwise cash advances, the reasons for James Cox's failure were almost certainly much more complicated. Because his Commissioners in Bankruptcy file has vanished, we

can only guess at the details, although his dealings with China in supplying richly jeweled gilt-metal clocks and "sing songs," and the difficulties he experienced with the Cantonese merchants, who were also slipping into insolvency, have long been recognised.[50]

If we are to believe James Cox's advertisements of 1772 for his "Museum of Mechanism and Jewellery" in London's Spring Gardens, its furnishing had already afforded "constant Employment to many Hundreds of ingenious Artists." This was at the moment of his greatest success. His stock impressed even Josiah Wedgwood, who thought it so far outshone the not-dissimilar productions of his friend Matthew Boulton that the latter was "under some little bit of an eclipse." The market in these wares held up for several years until the failure of Boulton's sale of ormolu at Christie's in May 1778. This seems to have been in response to a change in taste away from such expensive articles. Luckily for Boulton he had other interests, but Cox's almost concurrent collapse must surely have had serious repercussions within the manufacturing and retail goldsmiths' trade, at least for a while.

A Study in Success: Rundell, Bridge & Rundell

These events took place when Paul Storr was just seven or eight years old. By the time of Dru Drury's death in 1803 at the age of seventy-eight, the younger man was thirty-three, in the prime of life, and shortly to embark upon the most fruitful years of his career. In 1807 Storr entered into an exclusive manufacturing arrangement with Rundell, Bridge & Rundell, the royal jewelers, whereby he installed craftsmen in new jointly owned workshops in Dean Street, Soho, located in two converted adjoining early-eighteenth-century town mansions (FIGURE 7) about a mile and a half due west of the Rundell establishment at No. 32 Ludgate Hill. Besides Storr himself, the original partners in this concern, known as Storr & Co., were Philip Rundell (FIGURE 8), John Bridge, Edmond Waller Rundell, and the sculptor and designer William Theed,[51] who until lately had been employed by Wedgwood, the ceramics manufacturers.

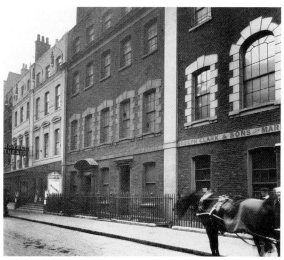

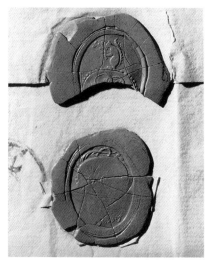

FIGURE 8. *Impressions in sealing wax of Philip Rundell's own seal*. Rundell may have adopted a squirrel for his crest as a reference to his personal application and success in business. *(Photo courtesy V & A Picture Library, London)*

FIGURE 7. *Nos. 75 and 76 Dean Street* (53 and 54 until 1818), ***Soho, London, in 1912***. Between 1807 and 1834 these buildings were ***the silver manufactory of Rundell, Bridge & Rundell***. From 1807 until early 1819 this business was styled Storr & Co., the original partners being Paul Storr, Philip Rundell, John Bridge, Edmond Waller Rundell, and William Theed. The houses, of which only No. 76 is still standing, were built as private residences between 1732 and 1735. *(Plate 102a, reproduced from* The Survey of London, *edited by C. R. Ashbee, et al., vol. 34, The Parish of St. Anne, Soho, London, 1966. Reproduced with permission, © Athlone Press, London.*

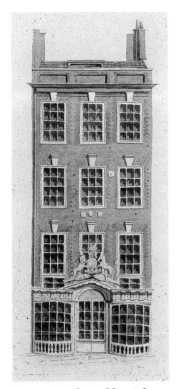

FIGURE 9. *The Golden Salmon, 32 Ludgate Hill, London, watercolor* by an unknown artist, ca. 1825. It was into this building, which dated from the early part of the eighteenth century, that Henry Hurt moved in 1745 from St. Paul's Churchyard. Eventually it became both the ***private residence of Philip Rundell and the headquarters of Rundell, Bridge & Rundell***, the firm of which he was chief partner until retiring in 1823. (*Collection of Mr. Richard Vanderpump, London; photo courtesy Sotheby's Picture Library, London*)

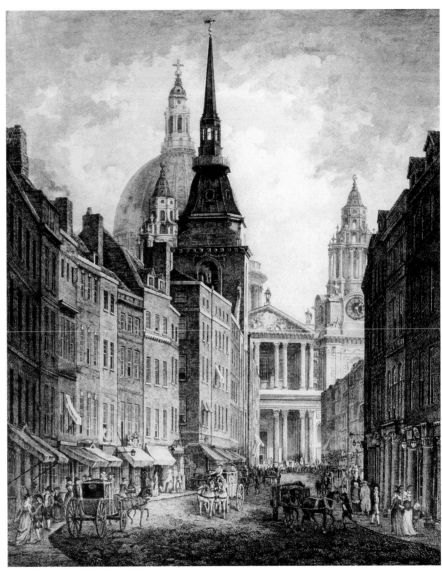

FIGURE 10. **View of St. Paul's Cathedral from Ludgate Hill**, *engraved by Thomas Morris* (pupil of Mr. Woollett) after William Marlow, Fellow of the Society of Antiquaries, published 17 February 1795, by John Curtis, Twickenham, Middlesex. ***The Golden Salmon, No. 32, the shop of Rundell & Bridge***, is to be seen on the north or left side of the street. In this view it is the building just behind the carriage to the left. (*Photo © Guildhall Library, London*)

Rundell's itself, during the early nineteenth century probably the most famous silversmith in the world, is thought to have been established in St. Paul's Churchyard at the end of the seventeenth century by a watchmaker named Noah Hurt. In time his son Henry took over and in 1745 transferred the business to the house on Ludgate Hill, No. 32 (FIGURES 9, 10), which, taking its name from the founder's premises, became celebrated as the Golden Salmon. By the time Philip Rundell arrived there from Somerset as a young man, the firm was in the hands of William Pickett. Pickett quickly found that his

new shopman had a genius for business and invited him to become a partner, with the result that until February 1786 the firm was known as Pickett & Rundell. (Three years later, Pickett's personal ambitions were realized upon being elected Lord Mayor of London.) Rundell was joined by another West Country native in the person of John Bridge, whereupon in December 1786 the business became known as Rundell & Bridge. For nearly forty years these two men formed what seems to have been the perfect working partnership, each attending to that part of the business to which his very different character best suited him. Rundell, hard-working, often irascible, and steadfast in striking a bargain, superintended the firm's jewelry and other manufacturing departments and was regarded by London contemporaries as the keenest judge of diamonds. Bridge, on the other hand, was possessed of an urbanity of manner that proved of the greatest importance, especially in the firm's dealings with George III and other members of the royal family.

About 1804–05 Edmond Waller Rundell (1768?–1857), Philip Rundell's nephew, became a partner in the firm and the name changed to Rundell, Bridge & Rundell. Besides a large stock of diamonds and other precious stones, pearls, jewelry, gold boxes, and objects of vertu, much of Rundell's business depended upon handling antique as well as new silver. We are told that the shop had "massive silver vases, &c. &c. strewed on the floor as if they were articles possessing neither external beauty, [n]or intrinsic value,"[52] and that this store exceeded "all others in the British Empire, if not in the whole world, for the value of its contents."[53] On occasions, when a special order or a new service of plate was put on display in the showrooms for the public's inspection, the narrow thoroughfare outside was jammed in the afternoons with fashionable carriages and the bustle of pedestrian traffic eager to see the treasures laid out within. In fact, the years immediately following the purchase of Duval's business about 1798 were so busy and successful, particularly in the plate department, that it was decided among the partners that Rundell's should come to some binding arrangement with a prominent manufacturing silversmith to supply work on a regular basis rather than having to rely on a number of independent outside contractors like Paul Storr.

The choice fell upon Benjamin Smith (1764–1823), a Birmingham chaser and buttonmaker who had previously been in business with Matthew Boulton. In 1801 or 1802 Smith and a partner, Digby Scott (ca. 1753–1816), established a factory in Lime Kiln Lane, Greenwich, southeast of the Tower of London on the other side of the River Thames. Here for the next five years or so an unknown number of craftsmen worked on commissions received directly from Rundell's on Ludgate Hill. The output was prodigious and of the finest quality, in both white silver and silver-gilt. According to Arthur Grimwade, their most important production was probably the Jamaica service of 1803, now in the Royal Collection.

Following the termination of its arrangement with Smith, Rundell's turned to Paul Storr to run its plate factory, and during 1807 his business and the firm on Ludgate Hill formally joined forces. On 23 October of that year the new Storr & Co. effected an insurance policy on premises 52 and 53 (later 75 and 76) Dean Street, Soho, wherein were detailed a "casting room under the yard behind" and "workshops all communicating in the said yard, stoves therein."[54] Business increased so much that in December 1809 the insurance policy writer was able to mention "New Workshops adjoining behind No. 53 Dean Street . . . intended to communicate with their other workshops"[55] (FIGURE 11).

In the course of the years 1806, 1807, and 1808, so great were the orders on Mr. Rundell, that without any exaggeration, upwards of one thousand hands were constantly employed in manufacturing for that firm, including diamond setters and cutters, jewellers, silversmiths, engravers, &c. &c. During one year, a single working jeweller's account amounted to upwards of eleven thousand pounds; and at a silver manufactory in Dean-street, Soho, belonging to Mr. Rundell, where the first artisans were employed, a contract was entered into with the conductors of the same, who had an interest in the quantity manufactured, to furnish a constant supply of ten thousand ounces of sterling silver monthly; which did not, however, prove adequate for the consumption required.[56]

And so it was that while the agreement lasted Paul Storr's mark appeared on much of the finest work in silver that was sold by Rundell, Bridge & Rundell between 1807 and 1819. The Gans Collection is happily rich in works from this period during which Storr & Co. flourished at the Dean Street factory. Particularly fine examples are the four silver-gilt candlesticks of 1808 – 09 ordered through Rundell's by Walter Sneyd of Keele Hall, Staffordshire,[57] and a version of John Flaxman's celebrated "Theocritus Cup" of 1811–12.[58]

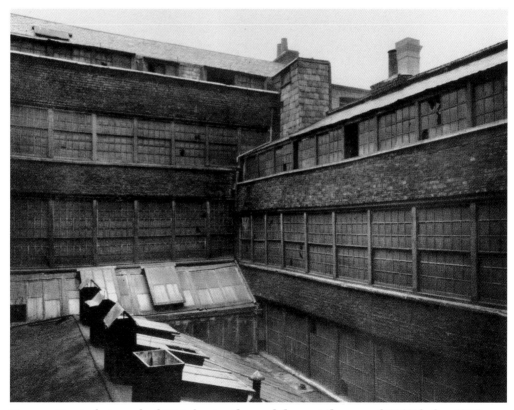

FIGURE 11. A photograph of 1912 showing ***the workshops at the rear of 75*** (53 before 1818) ***Dean Street, Soho***. This range of buildings, now demolished, is believed to have been erected about 1807, and probably part of those used by Rundell, Bridge & Rundell for the manufacture of silver. Between 1807 and late 1818 these workshops were part of the business styled Storr & Co., the original partners being Paul Storr, Philip Rundell, John Bridge, Edmond Waller Rundell, and William Theed. (*Plate 135c, reproduced from* The Survey of London, *edited by C. R. Ashbee, et al., vol. 34, The Parish of St. Anne, Soho, London, 1966. Reproduced with permission, © Athlone Press, London.*)

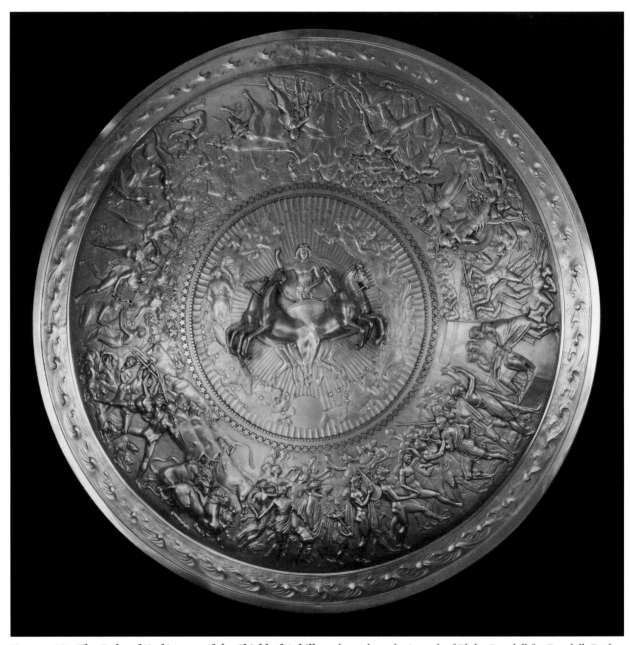

FIGURE 12. *The Duke of York's copy of the Shield of Achilles*, silver-gilt, maker's mark of Philip Rundell for Rundell, Bridge & Rundell, London, 1822–23, 36¼ in. diameter, 669 oz., 10 dwt. The reverse inscribed: "Designed & Modelled by John Flaxman, R.A. Executed & Published by Rundell, Bridge & Rundell, Goldsmiths & Jewellers To His Majesty, London MDCCCXXII." One of four made at Rundell's Dean Street, Soho, workshops, the other three being for George IV, the Duke of Northumberland, and Earl Lonsdale. (*Photo courtesy Huntington Library, Art Collections, and Botanical Gardens, San Marino, California*)

William Theed's death in 1817 robbed Rundell's Storr & Co. silver factory of a partner and its chief artist. Although he had worked for the firm for fourteen years—it is thought he also helped Benjamin Smith and Digby Scott in setting up the Greenwich factory— there is evidence that it was a difficult association. He told a friend, the landscape painter Joseph Farington "of the vast concerns of Rundle [*sic*] and Bridge, Silversmiths, with whom

He is concerned in business, He making the models to be executed in gold or silver.—He mentioned some inconvenience which He suffered from their intruding their opinions in matters of taste & design, & [said] He could always go one better if He had access to the Noblemen or Gentlemen who gave them Commissions and were easily lead [*sic*] to adopt His opinions."[59] Theed's was a difficult place to fill, for although Rundell's had made use of other artists, notably John Flaxman (1755–1826) and Thomas Stothard (1755–1834), few were familiar with the requirements of a business that translated ideas and two-dimensional designs into small, judiciously fashioned three-dimensional objects in precious materials. As mentioned, Theed had worked for Wedgwood; so, too, had Flaxman, and it was to him that Rundell's now turned. In his new capacity as artistic adviser he continued to supply designs and became interested in the artistic direction of the company's plate-working activities as a whole.

As Shirley Bury has shown in her article "The Lengthening Shadow of Rundell's," Flaxman was increasingly seduced by the Gothic[60] and Rococo[61] styles, although, of course, his name is usually associated with classical themes. While Paul Storr and Rundell's dissolved their partnership on 18 February 1819, Rundell's itself carried on the workshops in Dean Street under the direction of Cato Sharp, although for the moment the firm's silverwork produced there bore the so-called maker's mark of Philip Rundell in his capacity as senior partner (FIGURES 12, 13). Thus it fell not to Storr but to the little-known Sharp in 1822 to superintend the making of the silver-gilt Shield of Achilles (FIGURE 12), Flaxman's finest achievement in designing plate (for which he also uniquely supplied the model, FIGURES 14A, 14B), and certainly Rundell's great masterpiece.[62] In fact, the shield was replicated four times, copies being supplied to George IV, his brother the Duke of York, Earl Lonsdale, and the Duke of Northumberland.

Meanwhile Paul Storr had removed himself and his own workforce to a factory in Harrison Street, Grays Inn Road, north of Holborn, where he continued to oversee the manufacture of fine silver. During 1822 he also went into business as a retail goldsmith and jeweler in Bond Street with John Mortimer (died 1871). This partnership, which included the silver manufactory, traded under the name of Storr & Mortimer until Storr's retirement on 31 December 1838; subsequently the firm continued as Mortimer & Hunt and then Hunt & Roskell.

FIGURE 13. *Maker's mark of Philip Rundell* for Rundell, Bridge & Rundell, London, 1822–23, as seen on a *detail of the Duke of York's copy of the Shield of Achilles*, silver-gilt, 1822–23. (*Photo courtesy Huntington Library, Art Collections, and Botanical Gardens, San Marino, California*)

FIGURE 14A. *A drawing for the siege, ambuscade, and military engagement, Victory at the center*, by John Flaxman. (*Photo courtesy Huntington Library, Art Collections, and Botanical Gardens, San Marino, California*)

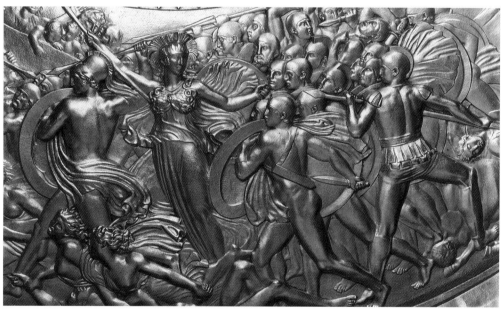

FIGURE 14B. Detail from *Shield*, showing the "Victory" scene as rendered by Flaxman, above. (*Photo courtesy Huntington Library, Art Collections, and Botanical Gardens, San Marino, California*)

As for Philip Rundell, from one who appears to have known him well, he

always manifested much pleasure in the enjoyment of female society, for which the comeliness of his person, his conversational powers, and his habitual attentiveness, naturally fitted him. He was unassuming in his manners, and when relieved from the cares of business, was a cheerful and agreeable companion. He was fond of music, had a tolerable voice, and sang with taste.[63]

During the last twenty years of his life, however, he suffered from increasing deafness and the effects of an internal complaint, in consequence of which "he withdrew much from society, and lived very retired."[64] Other, less-charitable accounts of Rundell's character, conduct, and the acquisition of his great personal wealth have survived, the most unpleasant

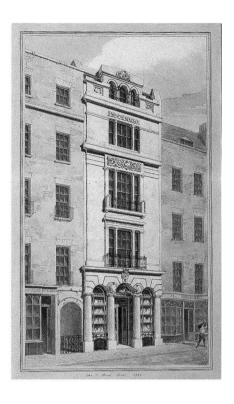

FIGURE 15. *The new premises of Rundell, Bridge & Rundell, 32 Ludgate Hill*, a watercolor by the architect John Clement Meade, 1826. (*Guildhall Library, London; photo courtesy Bridgeman Art Library International Ltd., London/New York*)

Rundell's closed for business at Christmas 1843, and the company was wound up two years later. No. 32 Ludgate Hill remained standing, with certain alterations, until its demolition in the 1890s. The whole area was later destroyed by enemy action during the Second World War, and the site of Rundell's, which is unmarked, is now covered by a modern office block and shops.

of which, perhaps significantly, were written by former employees. Rundell retired in 1823 and his health began to deteriorate seriously towards the end of 1826. He died on 17 February 1827, leaving an estate valued in excess of £1 million, an extraordinary amount for those days. His business did not long survive him, for although the Ludgate Hill premises were rebuilt in 1826 (FIGURE 15), it finally closed less than twenty years later at Christmas 1843.

In Conclusion

As we have seen, it was at this very period when old silver began to be appreciated in terms of its history as well as upon its merits as interesting or beautiful items from the past to be cherished. The work of Octavius Morgan and William Chaffers unraveled much of the mystery surrounding the hallmarks and makers' marks,[65] while other writers subsequently began to investigate the origins of designs and the progress of plate-working skills in former times. With these publications and the inevitable spread of knowledge there grew up the first generation of collectors for whom old English silver held a special charm. Americans in particular found its quality irresistible, and there were several avid collectors on this side of the Atlantic at the end of the nineteenth century. Although prices are no longer always reasonable,[66] the past fifty years have seen a golden age for a succeeding group of collectors: Judge Irwin Untermyer of New York, for instance, whose catalogue of seventeenth- and early-eighteenth-century English silver was published in 1963; Lillian and Morrie Moss of Florida, noted for an unrivalled collection of Paul Storr pieces (examples from which are now in the Gans Collection), whose catalogue was published in 1972; and Francine and Sterling Clark, whose collection in Williamstown, Massachusetts, has benefited greatly by the publication of a splendid new catalogue.[67]

In the context of collecting old English silver, Jerome and Rita Gans, another American couple, put together a world-class group. It has been informed by their love of silver and silver-gilt, by their appreciation of fine craftsmanship and beauty, and by their determination to eschew anything that failed their exacting standards. It is a collection of which they and the Virginia Museum of Fine Arts can be truly proud.

Notes

1. Joseph R. Bliss, *The Jerome and Rita Gans Collection of English Silver on Loan to The Virginia Museum of Fine Arts* (New York: ARN Publishing, 1992), 5 (hereafter cited as Bliss, *Gans Collection*).

2. Ibid., cat. no. 1, pp. 9–13.

3. Ibid., cat. nos. 74–76, pp. 216–23.

4. John Culme, *English Silver: The Jerome & Rita Gans Collection, Addendum* (Richmond: Virginia Museum of Fine Arts, 1999).

5. Bliss, *Gans Collection*, cat no. 77, pp. 224–26.

6. Charles Chichele Oman, *The English Silver in the Kremlin, 1557–1663* (London: Methuen, 1961); John Culme, ed., *English Silver Treasures from the Kremlin: A Loan Exhibition . . . from 1st January 1991 to 28th January 1991* ([London]: Sotheby's, 1991).

7. For an excellent account of the American silver trade, see Charles L. Venable, *Silver in America, 1840–1940: A Century of Splendor* (New York: Dallas Museum of Art, distributed by H. N. Abrams, 1995).

8. Manufactured on behalf of The Goldsmiths & Silversmiths Co. Ltd., of Regent Street, the service reappeared in London at Sotheby's Belgravia on 15 December 1977, lot 256.

9. These have been published many times, but see a detailed account and illustrations in Susan Hare, ed., *Paul de Lamerie: At the Sign of The Golden Ball: An Exhibition of the Work of England's Master Silversmith (1688–1751)*, Exhibition Held at Goldsmiths' Hall, . . . London, from 16th May to 22nd June 1990 ([London]: Goldsmiths' Company, 1990), no. 91, pp. 138–41.

10. Catalogue no. 2, acc. nos. 97.91.1a/c–2a/c.

11. Catalogue no. 1, acc. no. 97.91.

12. The first researcher in the field was Shirley Bury of the Victoria and Albert Museum, London, who began her work in the early 1950s; her three-part article, "The Lengthening Shadow of Rundell's" for *Connoisseur* (London), is as relevant today as it was when first published in 1966. See also Patricia Wardle, *Victorian Silver and Silver-Plate* (London: H. Jenkins, 1963, and New York: Universe Books, 1970); and my *Nineteenth-Century Silver* (London: Hamlyn for Country Life Books, 1977), and *The Directory of Gold and Silversmiths, Jewellers, and Allied Traders, 1838–1914: From the London Assay Office Registers* (Woodbridge, Suffolk: Antique Collectors Club, 1987).

13. The oldest is The Silver Society, founded as The Society of Silver Collectors in London in 1958. Similar societies are active in New York and Melbourne.

14. *A King's Feast: The Goldsmith's Art and Royal Banqueting in the 18th Century*, Catalogue of an Exhibition Held at Kensington Palace, [London], 5th June–29th September 1991 (Copenhagen: Den Kongelige Udstillings/The Royal Exhibition Fund, 1991).

15. It is to be regretted that the demands of the camera angles in this scene dictated that these candlesticks were not of any known eighteenth-century silver type, shape, or form. Instead Kubrick had to use a very short-stemmed candlestick unlike the tall-stemmed ones actually used in the eighteenth century.

16. Catalogue no. 3, acc. nos. 97.89.1; 2a/b–8a/b.

17. For a broad investigation of this subject, see my "Attitudes to Old Plate, 1750–1900," *The Directory of Gold and Silversmiths, Jewellers, and Allied Traders*, 1:xvi–xxxvi.

18. Recent changes in European Community law have compelled the British authorities to make certain fundamental changes to the system.

19. Clare Williams, trans. and ed., *Sophie in London, 1776: Being the Diary of Sophie v. la Roche* (London: J. Cape, 1933).

20. Horace Walpole, *A Catalogue of the Classic Contents of Strawberry Hill* ([London]: Smith and Robins, Printers, 1842), 23rd day, lot 36.

21. *Archaeological Journal* (London) 8 (1851): 197.

22. Octavius Morgan, *Table of the Annual Assay Office Letters* (London: Office of the Archaeological Institute of Great Britain and Ireland, 1853).

23. *Hall Marks on Gold and Silver Plate*, 2d ed., much enlarged (London: Davy, 1865), 56. The date of Paul de Lamerie's first mark was actually 5 February 1713. Chaffers used the date 1712 by mistake, not realizing that the Old Style (Julian) calendar was still in use prior to 1752 and that the year under that calendar officially ended on 24 March. In 1752 the New Style (Gregorian) calendar was adopted, which changed the end of the year to 31 December. Since the adoption of the latter calendar, earlier dates such as that for de Lamerie's first mark are rendered as 5 February 1712/13 or as 5 February 1713. For an explanation of the calendars, see Margaret Drabble, ed., *The Oxford Companion to English Literature*, rev. ed. (New York: Oxford University Press, 1995), Appendix II, "The Calendar." For a later discussion of Paul de Lamerie and his marks, see Hare, "Paul de Lamerie 1688–1751," in *Paul de Lamerie: At the Sign of The Golden Ball*, 8–15. For de Lamerie in Gerrard Street, now at the center of London's China Town, see Hare, "A Tribute to Paul de Lamerie," *Silver Society Journal* (London) 4 (autumn 1993): 160.

24. William Chaffers was the first to concentrate on this aspect of the subject. In *Gilda Aurifabrorum* (London: Allen, 1883), he published some fourteen hundred maker's marks from the London Makers' Marks Books, giving details of "their [owners'] Names, Addresses, and Dates of Entry," registered between 1697 and 1805.

25. *Gilda Aurifabrorum*, 167–68.

26. Arthur Grimwade, *London Goldsmiths, 1697–1837: Their Marks and Lives from the Original Registers at Goldsmiths' Hall and Other Sources* (London: Faber, 1976), 433. A third edition of Grimwade's book appeared in 1990 and further adjustments to the text as research allows are published from time to time in the *Silver Society Journal* (London).

27. John Culme, "Beauty and the Beast: The Growth of Mechanisation in the English Plate, Plated and Allied Industries," *Connoisseur* 196 (September 1977): 44–53.

28. Rosalind Laker, *The Silver Touch* (London: Methuen, 1987).

29. Hare, "Paul de Lamerie 1688–1751," in *Paul de Lamerie: At the Sign of The Golden Ball*, 15.

30. Ibid., 8–15.

31. Helen Clifford, "Paul de Lamerie and the Organization of the London Goldsmiths' Trade in the First Half of the Eighteenth Century," in *Paul de Lamerie: At the Sign of The Golden Ball*, 24–28.

32. Bliss, *Gans Collection*, cat. no. 29, pp. 87–92.

33. He actually moved there early in 1738, although he did not register the fact at Goldsmiths' Hall until entering a new mark on 27 June 1739.

34. The firm of George Wickes, founded in the early 1720s, which through its various changes of partnerships eventually became R. & S. Garrard & Co., has been the subject of several studies, including Elaine Barr, *George Wickes: Royal Goldsmith, 1698–1761* (London: Studio Vista, Christie's, 1980); Helen Clifford, "'The King's Arms and Feathers': A Case Study Exploring the Networks of Manufacture Operating in the London Goldsmiths' Trade in the Eighteenth Century," in *Goldsmiths, Silversmiths, and Bankers: Innovation and the Transfer of Skill, 1550 to 1750* (Stroud, Gloucestershire, and London: Alan Sutton Pub., Centre for Metropolitan History, 1995), 84–95; and Charlotte Gere, John Culme, and William Summers, *Garrard: The Crown Jewellers for 150 Years, 1843–1993* (London: Quartet Books, 1993). On 1 September 1998, Garrard's was formerly amalgamated with Asprey's of Bond Street, London, to become Asprey & Garrard.

35. Shirley Bury, "The Lengthening Shadow of Rundell's," parts 1, 2, and 3, *Connoisseur* 161 (1966): 79–85, 152–58, and 218–22.

36. *The Shorter Oxford English Dictionary on Historical Principles* (Oxford: Clarendon Press, 1993), describes a victualler as a purveyor of victuals or provisions, specifically the keeper of an eating house, inn, or tavern; one who supplies an army or armed force with necessary provisions, etc.

37. For a discussion of the Vulliamys, see Helen Clifford, "The Vulliamys and the Silversmiths, 1793–1817," *Silver Society Journal* 10 (autumn 1998): 96–102.

38. Between 1829 and 1841 the present Trafalgar Square was laid out beside this route slightly to the northwest of Charing Cross. "Before that time the area was a congestion of small alleys. . . . These were swept away." Wilfrid Douglas Newton, *London West of the Bars* (London: R. Hale, 1951), 164.

39. The son, the eccentric John Camden Neild (1780–1850), famously bequeathed some £250,000 to Queen Victoria. Robert Chambers, *The Book of Days . . .* (London and Edinburgh: W. & R. Chambers, 1866), 2:285–88.

40. Joseph Brasbridge, *The Fruits of Experience, or, Memoir of Joseph Brasbridge, Written in his 80th Year* (London: Printed for the author, A. J. Valpy, 1824), 142–43.

41. Public Record Office, Kew, Surrey, England, B[ankrupcy] 3/1257.

42. Quotations in this and the following paragraphs discussing his life and work are from "Letter-book of Dru Drury (1725–1803), 1761–1783, Being Copies, Nearly All in His Own Hand, of His Scientific and Other Correspondence," 96 q (Biog.), Entomological Library, Natural History Museum, South Kensington, London.

43. Certain other manufacturing silversmiths in London at this time, such as Hester Bateman and John Carter, are recorded as having bought Sheffield-made silver candlesticks for resale in London, and then having had them rehallmarked and stamped with their own makers' marks.

44. There is no modern equivalent to the eighteenth-century term *toyman*, which became more or less obsolete by the early nineteenth century. The toyman or toywoman usually owned a shop and retailed "toys": luxury goods such as buckles, buttons, items in mother-of-pearl or ivory, mounted walking canes, painted enamel boxes, scent flasks, and so forth. Of modest commercial value, these items were created by a toymaker in or mounted in gold, silver, gilt-metal, or Sheffield plate (i.e., silver-plated copper).

45. Abdy, another silversmith specializing in silver handles for knives, was also a maker of silver spoons and forks. His business was in Noble Street, close to Goldsmiths' Hall and Cheapside.

46. John Duval Sons & Co. was purchased about 1798 by Philip Rundell, in whose firm, Rundell & Bridge of Ludgate Hill, it became amalgamated.

47. As indicated in n. 44, a toy shop in the eighteenth century sold luxury goods, not playthings for children.

48. A gorget is a crescent-shaped badge in silver or silvered metal, sometimes gilt, which was once worn below the neck by serving army officers. It is thought that many of Drury's customers were military gentlemen.

49. A largeworker is a manufacturing or working silversmith who makes large items (e.g., coffee pots, salvers, cups) as opposed to a smallworker who specializes in making such small items as wine labels, sugar tongs, snuffboxes, and nutmeg graters. The term *plateworker* is synonymous with largeworker.

50. Captain A. R. Williamson, *Eastern Traders: Some Men and Ships of Jardine, Matheson & Company . . .* (N.p.: Jardine, Matheson & Co., 1975), 4–35.

51. By a curious twist of fate, William Theed was the son of another William Theed who had been in partnership between the late 1750s and the early 1770s with Philip Rundell's old partner, William Pickett.

52. Gentleman Many Years Connected with the Firm, *Memoirs of the Late Philip Rundell, Esq., Goldsmith and Jeweller to His Majesty . . .* (London: J. Fairburn, 1827), 8–9.

53. Joseph Nightingale, *London and Middlesex; or, An Historical, Commercial, & Descriptive Survey of the Metropolis of Great Britain . . .* (London: Printed for J. Harris et al., 1815), vol. 3, pt. 1, p. 631.

54. MS 11936/440 809339, Guildhall Library, London.

55. MS 11936/448 836894, Guildhall Library, London.

56. *Memoirs of the Late Philip Rundell*, 12.

57. Bliss, *Gans Collection*, cat. no. 33, pp. 100–03.

58. Ibid., cat. no. 36, pp. 108–11.

59. James Grieg, ed., *The Farington Diary*, 4th ed. (London: Hutchinson, 1927), 7:147.

60. Prominent among his forays into the Gothic is his design for the National Cup of 1824–25, of which two versions (one in the Royal Collection) survive. For the design, see Culme, *Nineteenth-Century Silver*, 136.

61. Flaxman's most outstanding achievement in the Rococo style was the great silver-gilt wine cistern designed under his direction and manufactured after his death by Rundell's for George IV in 1829–30; it is now on exhibition in the Tower of London. For an illustration, see Bury, "The Lengthening Shadow of Rundell's," pt. 2, p. 152.

62. For full details of the Shield of Achilles, see Sotheby's, London, May 3, 1984, lot 124 (The Duke of Northumberland's copy), and Shirley Bury and Michael Snodin, "Flaxman's Shield of Achilles," in *Art at Auction: The Year at Sotheby's, 1983–84* (London: Sotheby Publications, 1984).

63. *The Annual Biography and Obituary for the Year 1827*, vol. 11 (London: Longman, Hurst, Rees, Orme, and Brown, 1828).

64. Ibid.

65. For a discussion of the English use of the terms *hallmark* and *makers' marks*, see John Paul de Castro, *The Law and Practice of Hall-Marking Gold and Silver Wares* (London: Crosby Lockwood & Son, 1926).

66. For instance, Lord Lonsale's copy of the Shield of Achilles was sold at Christie's, London, in 1947 for £520, whereas that of the Duke of Northumberland, which appeared thirty-seven years later at Sotheby's, London, in 1984, realized £484,000.

67. Beth Carver Wees, *English, Irish, & Scottish Silver at the Sterling and Francine Clark Art Institute*, Williamstown, Mass., 1st ed. (New York: Hudson Hills Press, 1997).

The Catalogue

1. **COFFEE POT** *Silver*

Marks: 1. London; 2. sterling silver;
3. 1749–50; 4. maker's mark of Paul de Lamerie
(Grimwade, no. 2204)

Height: 7¾ in. (19.6 cm.); *width* 5¾ in. (14.6 cm.);
depth 4 in. (10 cm.)

Gross Weight: 14 oz. (435 gm.)

Accession number: 97.90

Provenance: Christie's, New York,
26 October 1992, lot 379.

Description and Construction
Raised baluster form, chased in relief on either
side with elaborated cartouches enclosing
Oriental figures, one holding a parasol; engraved
with the arms of Hyde; raffia-covered handle

From the number of surviving examples it is clear that this type of small baluster, or
pear-shaped, coffee pot, was very popular in England during the mid-eighteenth century.
As Beth Carver Wees has suggested, the presence of simple rim bases on such pots proba-
bly indicates that they were intended to be used on lamp stands.[1] In illustrating one of
1753–54 that has three small feet rather than a circular base, and that bears the maker's
mark of Edward Wakelin, Elaine Barr reminds us that the same shape was used by
contemporary porcelain manufacturers.[2] Michael Clayton was also of the opinion that the
numerous entries of the 1750s in the Wakelin/Garrard ledgers to "Turky" (Turkey) coffee
pots may have referred to such pieces, "whose lip spouts would be far better suited to
pouring [strong] Turkish coffee than that of the normal form of coffee pot with its spout
springing from half-way, or even lower down the body."[3]

Although de Lamerie was responsible for a number of pots of this form, including
another baluster example that is thought to have belonged to his own younger daughter,[4]
only three are known in which the design of the spouts derive from coffee-plant sprays.
While differing from each other in respect of their body decoration, the present example,
that in the Sterling and Francine Clark Art Institute,[5] and another that appeared at
Sotheby's, London, in 1969, all had spouts cast from the same pattern. The first two were
applied with identical cast coffee-sprig finials, and the third was furnished with a butterfly
finial. Furthermore, all three were made in 1749–50, whereas a fourth, with similar
spout, but with tapering cylindrical body and pine cone finial, dates from 1752–53. The
last mentioned, made the year after Paul de Lamerie's death, bears the maker's mark of
Phillips Garden.[6] All of these vessels appear to be related to a pencil design of the period
for a baluster coffee pot or hot water jug with coffee-spray spout, which survives in the
Victoria and Albert Museum, London.[7]

1. Beth Carver Wees, *English, Irish, & Scottish Silver at the Sterling and Francine Clark Art Institute*, Williamstown,
 Mass., 1st ed. (New York: Hudson Hills Press, 1997), no. 203, pp. 302–03. For examples of pots of similar form but
 with spreading bases, dating from 1757–58, 1758–59, and 1768–69, see the same, nos. 205, 206, and 207, pp. 305–07.

2. Elaine Barr, *George Wickes: Royal Goldsmith, 1698–1761* (London: Studio Vista, Christie's, 1980), 109.

3. Michael Clayton, *The Collector's Dictionary of the Silver and Gold of Great Britain and North America* (Feltham,
 N.Y.: Country Life, 1971), 74.

4. Sotheby's, London, 11 November 1993, lot 420.

5. Wees, *English, Irish, & Scottish Silver*, no. 203, pp. 302–03.

6. Christopher Hartop, *The Huguenot Legacy: English Silver, 1680–1760*, from the Alan and Simone Hartman
 Collection (London: Thomas Heneage, 1996), no. 82, pp. 332–35.

7. This design has been published several times, including: *Rococo: Art and Design in Hogarth's England, 16 May to
 30 September 1984, the Victoria and Albert Museum* (London: Trefoil Books [for] The Museum, 1984), G20, p. 115;
 Hartop, *The Huguenot Legacy*, 335; Wees, *English, Irish, & Scottish Silver*, 302.

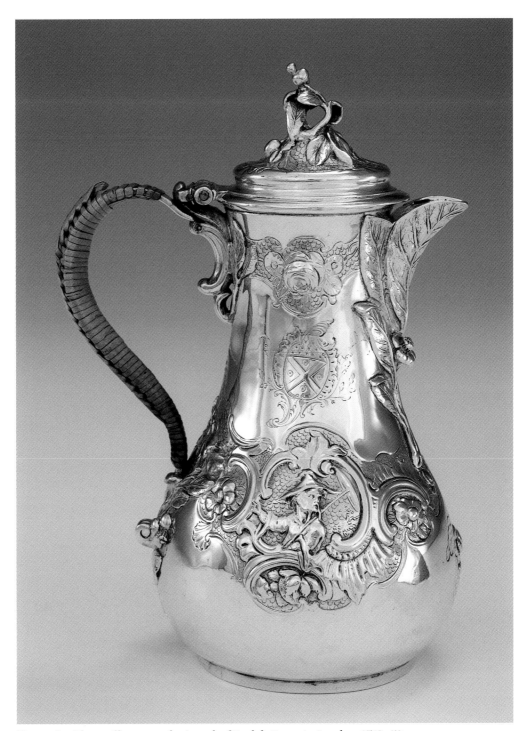

Figure 1. Silver coffee pot, maker's mark of Paul de Lamerie, London, 1749–50.

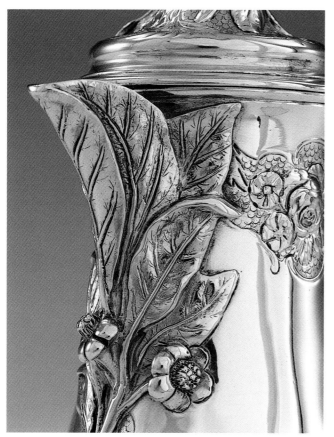

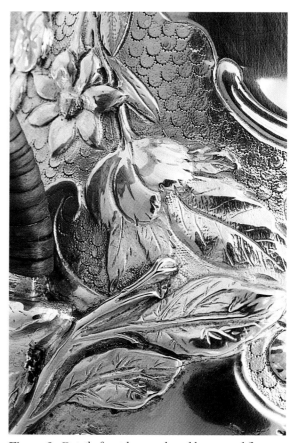

Figure 2. Detail of the cast and chased coffee-plant spray spout, with chased and textured background.

Figure 3. Detail of cast leaves, chased leaves, and flowers on the body at the base of the raffia-covered handle. Note the "fish scale" motifs achieved by the use of a serrated circular punch.

Figure 4. Detail, the engraved coat-of-arms of the Hyde family.

Figure 5. Detail of the underside of the coffee pot shows maker's mark and hallmarks:

Lower right: the maker's mark of Paul de Lamerie, entered at Goldsmiths' Hall, London, on 27 June 1739.

The hallmarks, *counter-clockwise from top:* (a) the mark of origin (crowned leopard's head, for London); (b) the date letter (o, for 1749–50); and (c) the standard mark (the lion passant, for sterling).

Figure 6. Detail of the inside rim of the coffee pot lid shows parts of the maker's mark (Paul de Lamerie, entered 27 June 1739), and the standard mark (the lion passant, for sterling).

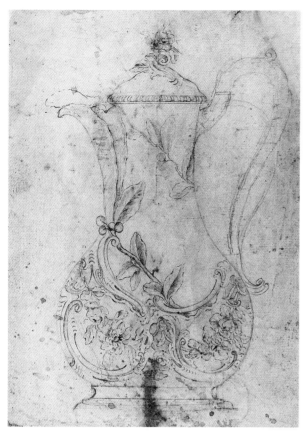

Figure 7. Design for a coffee pot or hot water jug, anonymous ca. 1750–1760, pencil, 235 x 156 cm. (*Photo courtesy V & A Picture Library, Victoria & Albert Museum, Department of Prints & Drawings, ref: 9052.9*)

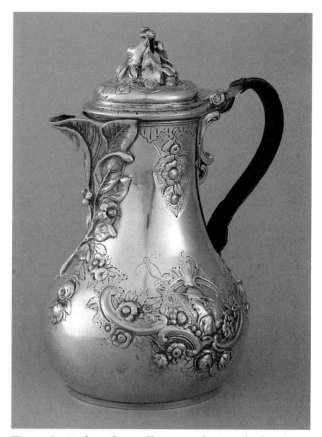

Figure 8. Sterling silver coffee pot, maker's mark of Paul de Lamerie, London, 1749/50. (*Photo courtesy The Sterling & Francine Clark Art Institute, Williamstown, Mass., accession no. 242*)

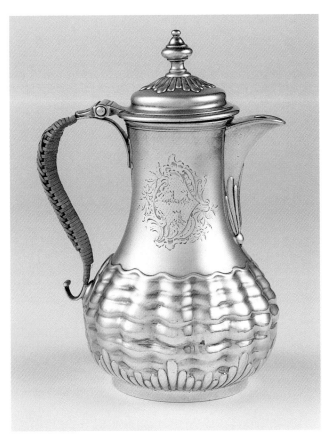

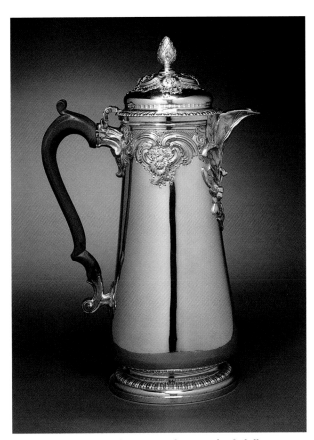

Figure 9. Sterling silver coffee pot, maker's mark of Paul de Lamerie, London 1749–50, engraved with the coat-of-arms of the de Lamerie family, London. The lozenge shape of the arms indicates that they were born by a female member of the de Lamerie family, probably one of Paul de Lamerie's daughters. (*Private collection*)

Figure 12. Sterling silver jug, maker's mark of Phillips Garden, London, 1752–53. (*Collection of Alan & Simone Hartman. Photo courtesy Christie's, New York*)

Figure 10. Detail of the engraved coat-of-arms of the de Lamerie family, London, as seen on the coffee pot illustrated above.

Figure 11. The engraved book plate of Mary de Lamerie, one of Paul de Lamerie's daughters. (*British Museum, London, Print Room, Franks Collection of Book Plates, no. 8403*)

2. PAIR OF FIGURAL CANDLESTICKS *Silver*

Marks: 1. London; 2. sterling silver; 3. 1748–49; 4. maker's mark of Paul de Lamerie (Grimwade, no. 2204), the detachable nozzles unmarked

Cast and chased, each candlestick on a triform base of scrolls and flowers rising to stems formed as caryatids, one male, the other female; further engraved with a coat of arms, the undersides engraved with the initial *J*

Height: 12⅞ in. (32.7 cm.); *width* 7¾ in. (19.6 cm.); *depth* 7½ in. (19 cm.)

TWO TWO-LIGHT CANDLESTICK BRANCHES

Description and Construction
No maker's mark; the sleeve of one struck with the lion passant, leopard's head and London date letter for 1736–37; all drip pans struck with the 1729–39 lion passant

Cast and chased, each composed of two scroll branches springing from a central shell and flame-capped element; the drip pans and sconces rising from small female caryatids; engraved with the initial *J*

Height of Candlesticks and Branches Combined: 17 in. (43 cm.); *width* 14¼ (36 cm.); *depth* 7½ in. (19 cm.)

Weight: 159 oz. 18 dwt. (4,973 gm.)

Accession number: 97.91.1a/c–2a/c

Provenance: The Earl of Liverpool, Christie's, London, 26 June 1973, lot 32.

The Dowty Collection, Christie's, New York, 22 April 1993, lot 61.

Exhibited: The Dowty Collection of Silver by Paul de Lamerie, Cheltenham Art Gallery & Museums, Cheltenham, England, 1983, catalogue by Timothy Schroder, no. 15, p. 21.

Paul de Lamerie: At the Sign of The Golden Ball: An Exhibition of the Work of England's Master Silversmith (1688–1751), Exhibition Held at Goldsmiths' Hall, London, from 16th May to 22nd June 1990, catalogue edited by Susan Hare, no. 115, p. 168.

The arms, confirmed by the presence of the initial *J*, are those of Jenkinson.

It has been suggested with some certainty that these candlesticks originally belonged to Charles Jenkinson (1693–1750) of Burford Lawn Lodge, Whichwood, Oxfordshire, England, a descendant of Anthony Jenkinson (died 1611), author of various vivid descriptions of travels in the Levant.[1]

Charles Jenkinson, third son of Sir Robert Jenkinson, 2nd Baronet, was a Colonel of the Royal Horse Guards at Dettingen. He married Amarantha, daughter of Captain Wolfran Cornewall, RN, by whom he had a son, also Charles (1727/29–1808), who rose to become a prominent politician. The latter, who took a leading part in establishing a commercial treaty between Great Britain and the first administration of the United States of America, was created Baron Hawkesbury in 1786, and Earl of Liverpool ten years later. His son and heir Robert (1770–1828) served as Prime Minister from 1812 to 1827.

Caryatid[2] pattern silver candlesticks, those whose stems are designed in the form of human or half-human figures, were among the most elaborate and costly available to English silversmiths' customers of the eighteenth century. Early examples made in London date from the latter part of the previous century, and by the 1740s and 1750s the form had become an established favorite. Of the present examples Timothy Schroder has written that although "very similar in inspiration to sticks by other makers, it is probably safe . . . to assume that the model was de Lamerie's own. Certainly the modeling of the base and the lower part of the stem is very much in his manner."[3] Another, virtually identical pair by de Lamerie, also of 1748–49, is in the Ashmolean Museum, Oxford. A further

1. E. D. Morgan and C. H. Coote, eds., *Early Voyages and Travels to Russia and Persia, by Anthony Jenkinson and Other Englishmen. With Some Account of the First Intercourse of the English with Russia and Central Asia by Way of the Caspian Sea*, ser. 1, nos. 72–73, 2 vols. (London: Hakluyt Society, 1886).

2. In architecture, a caryatid is a "female figure used as a column to support an entablature" (*Oxford English Dictionary*).

3. Timothy Schroder, *The Dowty Collection of Silver by Paul de Lamerie* (Cheltenham, Eng.: Cheltenham Art Gallery & Museums, 1983), 21.

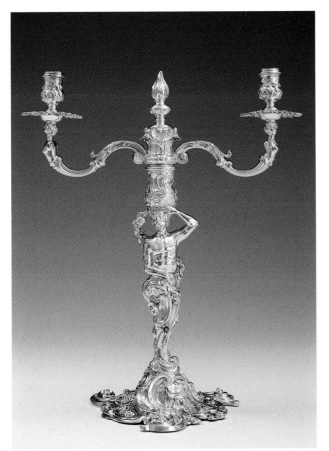

Figure 1. Sterling silver candelabrum: the candlestick with male figure, maker's mark of Paul de Lamerie, London, 1748–49. The detachable branches without maker's mark, the internal branch sleeve (hidden below the central finial) struck with the lion passant, leopard's head, and London date letter for 1736–37.

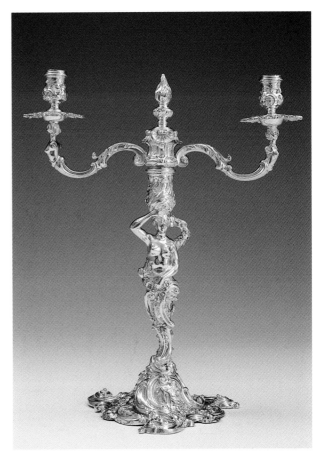

Figure 2. Sterling silver candelabrum: the candlestick with female figure, maker's mark of Paul de Lamerie, London, 1748–49; the detachable branches without marks, ca. 1736–37.

pair of comparable candlesticks, dating from 1752, the year of Paul de Lamerie's death, however, has been recorded as bearing the maker's mark of Frederick Kandler,[4] hinting at cross-currents in the silver manufacturing trade, the complications of which scholars have only lately become fully aware.

The inspiration for these and other similar candlesticks probably derives from the work of the artists Jacques Androuet Ducerceau (ca. 1515–1585) and Jean le Pautre (1618–1682), whose designs for caryatids survive in printed form, including the latter's *Nouveau Livre de Termes* of 1676. An engraving by Daniel Marot (ca. 1663–1752) of about 1712, which includes four *Grand Gairidons*, is another contender that itself may have been inspired by le Pautre.[5]

4. These sticks are in the Ashmolean Museum, Oxford, England, noted in Christie's, New York, auction catalogue of the Dowty Collection, 22 April 1993, lot 61, note.

5. Susan Hare, ed., *Paul de Lamerie: At the Sign of The Golden Ball: An Exhibition of the Work of England's Master Silversmith (1688–1751)*, Exhibition Held at Goldsmiths' Hall, . . . London, from 16th May to 22nd June 1990 ([London]: Goldsmiths' Company, 1990), no. 115, p. 168, note probably by Beth Carver Wees.

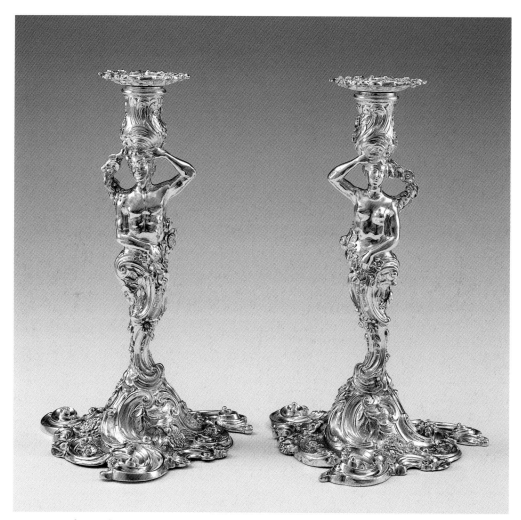

Figure 3. The candelabra bases or candlesticks fitted with detachable nozzles. The sticks, maker's mark of Paul de Lamerie, London, 1748–49; the nozzles without marks, ca. 1748–49.

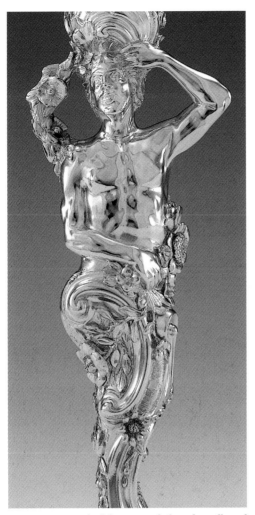

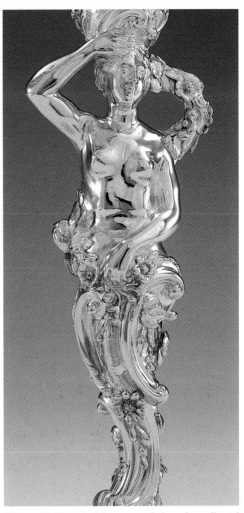

Figure 4. Detail of the cast and chased candlestick stem, with male figure, scrolls, and flowers.

Figure 5. Detail of the cast and chased candlestick stem, with female figure, scrolls, and flowers.

Figure 6. Closer detail of one of the stems, with the engraved coat-of-arms of the Jenkinson family.

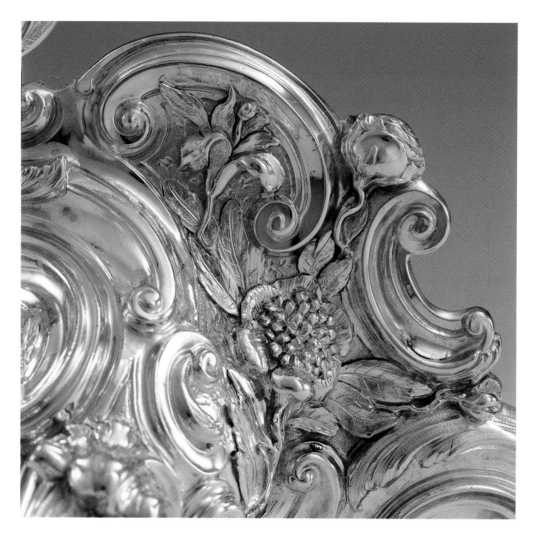

Figure 7. Detail of one of the cast and chased candlestick bases, showing scrolls, flowers, and foliage in relief.

Figure 8. Detail of one of the nozzles, with the engraved crest of the Jenkinson family.

Figure 9. Detail of one of the nozzles, with cast and chased border of a rose and foliage in relief.

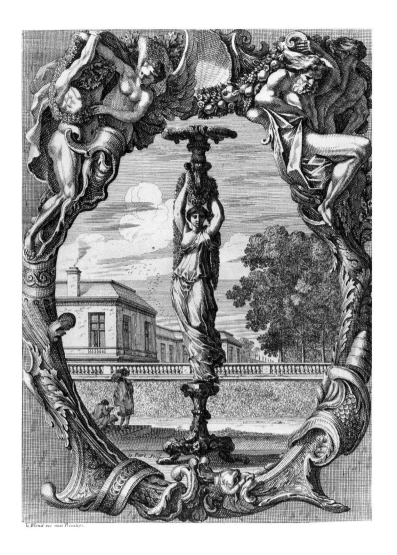

Figure 11. Jean le Pautre (1618–1682), design for a caryatid stand or candelabrum, perhaps from *Nouveau Livre de Termes*, 1676, etching. (*Photo courtesy V & A Picture Library, Victoria and Albert Museum, E.6703–1908*)

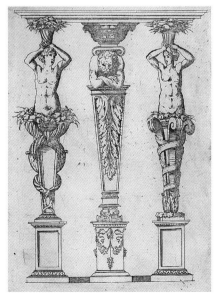

Figure 10. Jacques Androuet Ducerceau (ca. 1515–1585), two caryatids and a herm, etching. (*Photo courtesy V & A Picture Library, Victoria and Albert Museum, E.1211–1923*)

3. PUNCH SET
*comprising a circular stand, and
seven cups with detachable liners*

Silver-gilt

Marks: 1. London; 2. sterling silver; 3. 1820–21;
4. maker's mark of Philip Rundell (Grimwade,
no. 2228) for Rundell, Bridge & Rundell, the base
of the stand stamped "RUNDELL BRIDGE ET
RUNDELL AURIFICES REGIS LONDONI,"
further stamped "3"; the undersides of the stand, cups
and liners each engraved in freehand script "6366"

Height of Stand: 4¼ in. (10.7 cm.);
diameter 10⅛ in. (25.8 cm.)

Height of Stand with Cups: 6⅞ in. (17.5 cm.);
diameter 10⅛ in. (25.8 cm.)

Height of Each Cup: 2¾ in. (7 cm.); *diameter
with handles* 2¹⁵/₁₆ x 3¾ in. (6.8 x 9.5 cm.)

Weight of Entire Punch Set: 99 oz. (3,088 gm.)

Accession number: 97.89.1; 2a/b–8a/b

Provenance: Christie's, New York,
18 October 1994, lot 287

Description and Construction
The stand applied with cast, pierced and chased
borders of anthemions (honeysuckle motifs) and
other formal decoration; the cups each applied
with cast vine-stem handles issuing from bodies
die-stamped with tendrils bearing bunches of
grapes and matted vine leaves

The history of the celebrated London goldsmiths Rundell, Bridge & Rundell has yet to be
written. In brief, however, it appears that the firm was established toward the end of the
seventeenth century by a clockmaker named Noah Hurt. Philip Rundell (1746–1827) joined
the business in or shortly after 1767, by which time it was owned by William Pickett. He
became Pickett's partner in 1771 when the firm was styled Pickett & Rundell. Pickett
retired from business in 1786 whereupon Rundell took John Bridge (1755–1834) as partner,
and the style of the firm became Rundell & Bridge. Rundell's nephew, Edmond Waller
Rundell (ca. 1768–1857), whose mother, Maria Eliza Rundell (1745–1828), wrote a best-
selling cookery book, became a partner in 1804 or 1805, when the style was changed to
Rundell, Bridge & Rundell. Philip Rundell retired on 29 September 1823. Following John
Bridge's death in 1834 the firm's name was changed to Rundell, Bridge & Co., which it
remained until closing at Christmas 1843. The business was formally wound up in 1845.[1]

Philip Rundell entered his mark at Goldsmiths' Hall on 4 March 1819, a few days
after Paul Storr's withdrawal as head of the firm's manufacturing subsidiary, Storr & Co.,
in Dean Street, Soho.

The scratched "6366" on the bases of the various items in this punch set is believed to
be from a long series of numbers used by Rundell's to keep track of its stock of new and
secondhand silver. It is to be regretted that the company's ledgers in which these numbers
must have been recorded, alongside details of purchasers' names and many other details, do
not appear to have survived. It is very probable that they would have been destroyed in 1845.[2]

1. The most recent account of Rundell's history is to be found in a reprint of an obituary of Philip Rundell that first
 appeared in *The Annual Biography and Obituary for the Year 1827*, vol. 11, published in London by Longman,
 Hurst, Rees, Orme, & Brown in 1828. This reprint, with additions by the present writer, appeared as "A
 Devoted Attention to Business: An Obituary of Philip Rundell" in the *Silver Society Journal* (London) 2
 (winter 1991): 91–102. See also Sarah Tanner, "A Man Who Never Was" in the same issue, pp. 89–90; and N. M.
 Penzer, *Paul Storr: The Last of the Goldsmiths* (London: Batsford, 1954), chapter 4, which, in the light of later
 researches, should be read with care.
2. For further comment on the function of these and other numbers found engraved and stamped on certain items of
 English silver from the end of the eighteenth century, see my "Beauty and the Beast: The Growth of Mechanisation
 in the English Plate, Plated and Allied Industries," *Connoisseur* (London) 196 (September 1977): 44–53.

Figure 1. Silver-gilt punch set, maker's mark of Philip Rundell for Rundell, Bridge & Rundell, London, 1820–21

Figure 2 (*right*). Detail of the underside of the stand shows maker's mark and hallmarks:

Lower center: the maker's mark of Philip Rundell for Rundell, Bridge & Rundell. Note that the irregular outline of the mark, which would originally have been rectangular with slightly cut corners, indicates that the steel punch with which it was made had been chipped in several places.

The hallmarks, *clockwise from left:* (a) the mark of origin (crowned leopard's head, for London); (b) the date letter (e, for 1820–21); (c) the standard mark (the lion passant, for sterling); and (d) the duty mark (the sovereign's head, that of George III, signifying that the appropriate duty has been paid).

Right center, stamped "3."

Figure 3. Detail of underside of stand shows *6366* scratch-engraved or drawn freehand— Rundell's stock number from a long series, the key to which has been lost.

Figure 5. Part of the top of the stand, showing sections of the applied cast and die-stamped border details.

Figure 4. Detail of the underside of the stand, showing applied stamped and pierced border of anthemions.

Figure 6 *(above).* The edge of the stand base, showing Rundell's Latin retailer's mark: "RUNDELL BRIDGE ET RUNDELL AURIFICES REGIS LONDONI."

Figure 7 *(right).* The underside of one of the cup liners, showing *6366* scratch-engraved or drawn freehand (see Figure 3, *left*), and the assay scrape.

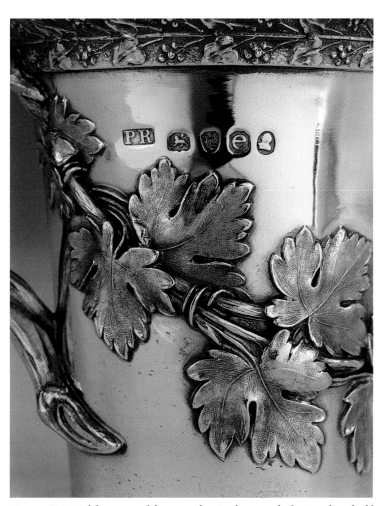

Figure 8. Detail from one of the cups, showing lower end of cast and applied handle, and part of the die-stamped vine tendril and matted vine-leaf decoration. *Above:* the maker's mark of Philip Rundell for Rundell, Bridge & Rundell; and the hallmarks: the standard mark (the lion passant, for sterling); the mark of origin (crowned leopard's head, for London); the date letter (e, for 1820–21); and the duty mark (the sovereign's head, that of George III, signifying that the appropriate duty has been paid).

4. PAIR OF CUPS AND COVERS *Silver-gilt*

Marks: 1. London; 2. sterling silver; 3. 1809–10; 4. maker's mark of Robert Garrard (Grimwade, no. 2320), in mid-eighteenth-century style, the otherwise plain spreading-circular bases and baluster bodies applied with cast, burnished and chased grape-bearing vines springing from woody handles, similarly decorated detachable covers, the bodies and covers further engraved with a crest

Height: 16¼ in. (40.5 cm.); *depth* 7¾ in. (19.7 cm.)

Weight: 234 oz. 8 dwt. (7,290 gm.)

Accession number: 97.86.1a/b–2a/b

Provenance: Christie's, London, 29 June 1955, lot 121, the property of the 3rd Earl of Ancaster, removed from Grimsthorpe, Lincolnshire.

Carrington & Co. Ltd., silversmiths, 130 Regent Street, London, W1.

Sotheby's, London, 9 November 1995, lot 190, from the estate of the late Lady Beaverbrook.

Description and Construction

The crest is that of Willoughby, Barons Willoughby de Eresby, probably for Peter Robert, 21st Baron Willoughby de Eresby (1782–1865), who succeeded to the title upon the death of his mother, Priscilla, Baroness Willoughby de Eresby, in 1828. He married on 19 October 1807 Clementina Sarah, daughter and sole heiress of James Drummond, 1st Lord Perth. Their grandson, Gilbert Henry, 24th Baron Willoughby de Eresby, was created Earl of Ancaster in 1892.

The general form of these cups may be compared with certain similar vessels that first made their appearance in English silver during the late 1730s and early 1740s. Although unmarked, an early example (the cup and cover presented by Frederick, Prince of Wales [1707–1751], to commemorate his visit to the City of Bath in 1738) was originally sold by the goldsmith George Wickes, in whose ledger it is recorded. According to Elaine Barr, however, and in spite of this apparently incontrovertible evidence, the piece "has been the subject of much controversy [and] many scholars believe it to be the work of Paul de Lamerie."[1] Among de Lamerie's oeuvre, there are indeed several such cups and covers, including one of 1742–43 in the Gans Collection.[2]

The design of the present Garrard cups appears to have been inspired by various such vessels made in the 1760s by or for the firm of George III's goldsmith, Thomas Heming of the King's Arms, Bond Street, London. As Philippa Glanville and Hilary Young of the Victoria and Albert Museum, London, have made clear, Heming, or more probably his designer, may well have drawn on his knowledge of English Rococo silver of the 1730s and 1740s, such as the aforementioned pieces from Wickes and de Lamerie.[3] Heming's engraved trade card of about 1761 features a similar cup and cover to the pair of 1809–10 from Garrard's in the Gans Collection, whose chief difference lies in the fact that its handles and lid are surmounted by figures of cherubs.[4]

1. Elaine Barr, *George Wickes: Royal Goldsmith, 1698–1761* (London: Studio Vista, Christie's, 1980), 158, fig. 100.

2. Joseph R. Bliss, *The Jerome and Rita Gans Collection of English Silver on Loan to The Virginia Museum of Fine Arts*, (New York: ARN Publishing, 1992), cat. no. 17, pp. 54–57. Identical cups and covers of the same date are in the Metropolitan Museum of Art, New York (Bequest of Alfred Duane Pell, 1925), and in the Clark Art Institute, Williamstown (Beth Carver Wees, *English, Irish, & Scottish Silver at the Sterling and Francine Clark Art Institute*, Williamstown, Mass., 1st ed. [New York: Hudson Hills Press, 1997], no. 28, pp. 80–81). See also another de Lamerie cup and cover, one of a pair of 1742–43, from the Indianapolis Museum of Art, illustrated in Christopher Hartop, *The Huguenot Legacy: English Silver, 1680–1760, from the Alan and Simone Hartman Collection* (London: Thomas Heneage, 1996), 200.

3. Philippa Glanville, *Silver in England* (London: Unwin Hyman, 1987), 243–45; Hilary Young, "Thomas Heming and the Tatton Cup," *Burlington Magazine* (London) 125 (May 1983): 285–89.

4. For a reproduction of this card, see Sir Ambrose Heal, *The London Goldsmiths, 1200–1800* (Cambridge, Eng.: The University Press, 1935), pl. XXXVIII, opposite p. 174. For an example of a silver cup and cover of similar design, the maker's mark overstruck by that of Thomas Heming, London, 1767–68, see Christie's, New York, 18 October 1994, lot 426.

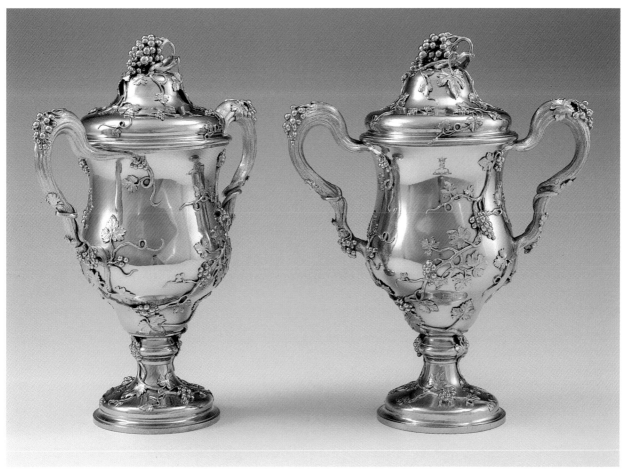

Figure 1. Pair of silver-gilt cups and covers, maker's mark of Robert Garrard, London, 1809–10.

Figure 2. Detail of one of the engraved crests of Willoughby, Barons Willoughby de Eresby: an elderly man, head and shoulders, crowned.

Figure 3. A section of one of the cup bodies, showing a burnished (i.e., polished) ground applied with cast, burnished and chased vine tendrils with bunches of grapes and leaves. Note the slightly rippled surface of the cup immediately adjacent to the applied castings. This feature was caused by the burnishing tool, a specially shaped, highly polished pebble of agate fixed with hard wax to the end of a wood rod.

5. CHAMBER POT AND COVER
or: *Soup Tureen and Cover*

Silver

Marks: 1. London; 2. Britannia standard;
3. 1818–19; 4. maker's mark of Robert Garrard
(Grimwade, no. 2323)

Height: 8¼ in. (21 cm.); *width* 12¾ in. (32.4 cm.);
diameter 10 in. (25.4 cm.)

Weight: 90 oz. (2,799 gm.)

Accession number: 97.92a/b

Provenance: O. F. York, Esq., Sotheby's, London,
12 May 1966, lot 12.

Description and Construction
Circular, on wide-spreading base, the compressed
body engraved on either side with a coat of arms
within a Rococo cartouche and applied with two
cast branch and leaf handles, the detachable cover
decorated with radiating flutes below a stylized
foliate handle, further engraved with three crests.

The arms are those of York impaling Lascelles for Richard York of Wighill Park, Yorkshire,
who married Mary Anne, daughter of Edward Lascelles, 1st Earl of Harewood, in 1801.
Richard York was High Sheriff of Yorkshire in 1832, and sometime Mayor of Leeds when,
according to family tradition, this chamber pot was provided for his use in the mayoral coach.
The latest scholarship, however, has thrown serious doubt on this function, suggesting
instead that the vessel is a soup tureen.

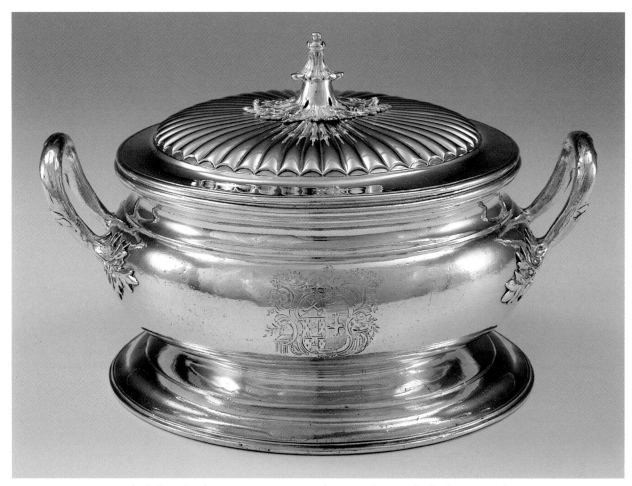

Figure 1. Britannia standard silver chamber pot or soup tureen and cover, maker's mark of Robert Garrard,
London, 1818–19.

Figure 2. Detail of one of the engraved crests of the York family on the lid.

Figure 4. Detail of the underside of the vessel showing maker's mark and hallmarks:

Center: the maker's mark of Robert Garrard.

The hallmarks, *clockwise from left:* (a) the mark of origin (the leopard's head erased, for London); (b) the standard mark (Britannia, for Britannia standard); (c) the date letter (c, for 1818–19); (d) the duty mark (the sovereign's head, that of George III, signifying that the appropriate duty has been paid).

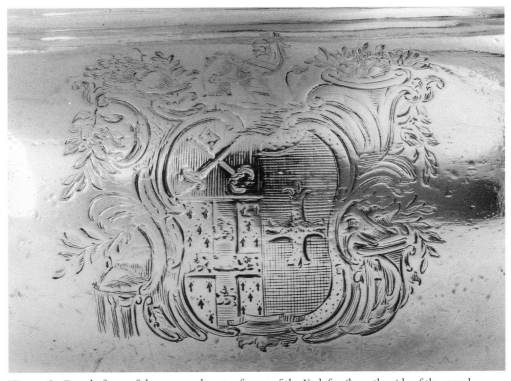

Figure 3. Detail of one of the engraved coats-of-arms of the York family on the side of the vessel.

6. SET OF FOUR VEGETABLE DISHES AND COVERS *Silver*
with handles, heater bases, and silver hot plates

Marks: 1. London; 2. sterling silver; 3. 1828–29; 4. maker's mark of Robert Garrard (Grimwade, no. 2322) for R., J. & S. Garrard, otherwise Robert Garrard & Brothers, the dishes, bases, and covers each stamped: "GARRARDS Panton Street London"; one hotplate an unmarked modern replacement; the heater bases stamped respectively 1 to 4, scratch engraved: "oz 83-14," "oz 83-0," "oz 83-14," and "oz 83-18"; the modern hotplate unnumbered, the remainder stamped respectively 2, 3, and 4; the dishes unnumbered, respectively scratch engraved: "oz 29-19," "oz 30-17," "oz 31-7," and "oz 29-13"; the covers stamped respectively 5 to 8, scratch engraved: "oz 32-14," "oz 32-12," "oz 31-19," and "oz 32-9," fitted with handles stamped 5 to 8

Overall Height: 9¼ in. (23.5 cm.); *diameter* 11¼ in. (28.5 cm.); *width over handles* 13 in. (33 cm.)

Weight: 542 oz. 10 dwt. (16,873 gm.)

Accession number: 97.88.1a/d–3a/d; 4a/f

Provenance: Christie's, New York, 22 April 1993, lot 308.

Description and Construction
Circular or shaped circular; the bases each on four cast foliate scroll supports between two similar applied handles, further engraved on either side with a crest below bands of die-pierced leaves and scrolls; the dishes similarly engraved and applied with cast gadroon and shell borders, the undersides later engraved "F.G.C."; the domed fluted covers each engraved on either side with a coat of arms, crest, motto, and supporters below detachable scroll handles with butterfly nuts.

The arms are those of Walter Francis Montagu-Douglas-Scott, 5th Duke of Buccleuch, who succeeded to the title upon the death of his father in 1819. He was born on 25 November 1806 at Dalkeith House where in 1822, aged sixteen, he had the honor of entertaining his monarch, George IV, for two weeks.

Educated at Eton and St. John's College, Cambridge, the Duke was appointed Lord Lieutenant of Midlothian in 1828. He was married on 13 August the following year at the fashionable London church of St. George's, Hanover Square, to Charlotte Anne, third and youngest daughter of Thomas, 2nd Marquess of Bath. Among other official posts, he was Captain General of the Royal Body Guard of Archers in which capacity he carried the gold stick at the coronations of William IV and Queen Victoria, respectively, in 1830 and 1837.

The Duke of Buccleuch died at one of his country seats, Bowhill, County Selkirk, in his seventy-eighth year, on 16 April 1884, being at the time the Senior Knight of the Garter. The total value of his estates was then in excess of £910,000.

The design of entrée dishes and covers, and vegetable dishes and covers such as these, appear to have been adapted from those of chafing dishes (stewpans) of the late seventeenth and early eighteenth centuries. Michael Clayton notes that "by 1770, probably owing to a growing tendency to eat privately and with fewer servants in attendance, the entrée dish with cover makes its appearance in sets, usually of four."[1]

Rectangular, circular, octagonal, or hexagonal, many supplied with heater bases, the form of these dishes and their accessories was already well established by the time Garrard's purchased a remarkable antique silver surtout[2] of nineteen pieces at a Christie's auction in

1. Michael Clayton, *The Collector's Dictionary of the Silver and Gold of Great Britain and North America* (Feltham, N.Y.: Country Life, 1971), 119.

2. A centerpiece for a table, although in this instance it comprised a number of distinct components in the form of stands for fruit, and so forth.

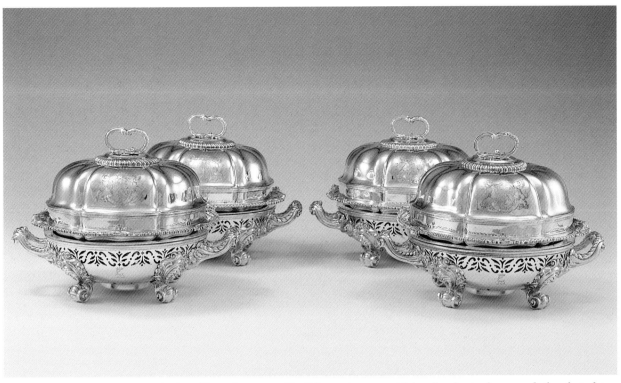

Figure 1. Set of four silver vegetable dishes and covers, with handles, heater bases, and silver hot plates, Robert Garrard for R., J. & S. Garrard, otherwise Robert Garrard & Brothers, London, 1828–29

Figure 2. Detail, underside of one of the heater bases, showing:

Garrard's stamped retailer's mark, "GARRARDS Panton Street London"; *center,* the maker's mark of Robert Garrard (RG below a crown) for R., J. & S. Garrard, otherwise Robert Garrard & Brothers.

The hallmarks, *clockwise from left:* (a) the mark of origin (uncrowned leopard's head, for London); (b) the standard mark (the lion passant, for sterling); (c) the date letter (n, for 1828–29); and (d) the duty mark (the sovereign's head, that of George IV, signifying that the appropriate duty has been paid). *Right,* the scratch weight, "oz 83-14" (83 troy ounces, 14 pennyweights). Notice that the 14 pennyweights had originally been 17 pennyweights.

SET OF FOUR VEGETABLE DISHES AND COVERS, continued:

London in April 1829. Although the group had belonged to Lord Gwydir (died 1820), it had in fact been made by the Lille silversmith Elie Pacot in 1709–10, more than a century before.[3] Part of the surtout comprised four octagonal stands that, for purposes of resale, Garrard's converted into heaters and added dishes and covers to match.[4] Whereas the decoration of the present vegetable dishes is relatively simple, relying on foliage, gadroons, and shells for the cast feet, handles, and borders, the Pacot pieces were in the style favored during the French Regency of the early eighteenth century, in which strapwork, paterae, human profiles, and other classical motifs were combined to create objects of great formality. Nevertheless, these Garrard vegetable dishes that have just been added to the Gans Collection (good representative examples of the firm's productions during the second quarter of the nineteenth century), display a serious, almost academic approach to design, mirrored by the Pacot stands, for which the firm became celebrated.

Working in what was tantamount to a house style, uncompromising in its formality, Garrard's seems to have aimed to appeal to a traditional, often aristocratic clientele for whom good workmanship and established patterns were better appreciated than innovative design. After all, at the end of 1843 the firm was bestowed with a new title—that of "Royal Goldsmiths"—immediately following the closure of its old rival, Rundell, Bridge & Co. A comment on Garrard's display at the Great Exhibition of 1851 emphasizes the point: "There is, among the articles made in silver by Messrs. Garrard . . . [a] table-candlestick with three branches, in the Queen Anne style, well conceived and very finely executed. A candlestick without branches, of a hexagonal shape, very well made, in repoussé work . . . Several other durable and well-made trays and tea-services . . . [and] several covered dishes, one of them of hexagonal shape, the others of the patterns known as the 'bead and scroll' and the 'bead and shell,' show the care and solidity with which plate for the table is made in England."[5] By comparison, the same authority found among the works of Garrard's two closest rivals objects of a very different nature. Whereas Hunt & Roskell were lavishly praised for having shown a vase in silver made for them by the contemporary French metalworker, Antoine Vechte (1799–1868), Charles Frederick Hancock, for "the variety and versatility of style observable in his works," was commended for "respecting the traditions of English art" while proving himself "desirous of introducing into it improvements of a special kind."[6]

3. For a full discussion of the surtout, see Nicole and Isabelle Cartier, "The Elie Pacot Surtout," *Silver Society Journal* (London) 5 (winter 1994): 296–301.

4. Ibid., 300, fig. 8. The stands with their new dishes and covers were sold to Viscount Combermere of Bhurtpore (1773–1865).

5. *Exhibition of the Works of Industry of All Nations, 1851: Reports by the Juries . . .* (London: William Clowes, 1852), 512.

6. Ibid., 513. The vase by Antoine Vechte, known as the Titan Vase, was eventually given by Hunt & Roskell to the Worshipful Company of Goldsmiths, London, in whose collection it remains.

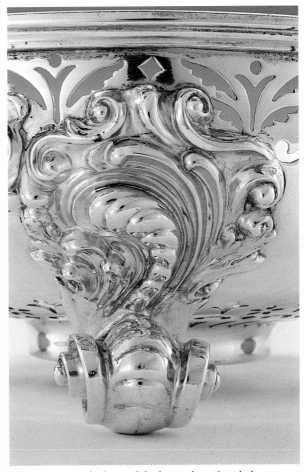

Figure 3. Detail of one of the heater base feet, below a border of die-pierced motifs.

Figure 4. Detail of one of the heater base feet, below a border of die-pierced motifs; another angle.

Figure 5. Detail of die-pierced motifs on heater base. Note the regular outlines of the shapes, which indicate that the piercing was achieved by machine rather than by hand with a saw. Note also the slight but identical imperfection to each of the seven teardrop motifs at the base of the photograph, caused by a small flaw in the edge of the steel punch.

Figure 6. Detail of the coat-of-arms, motto, and supporters on one of the vegetable-dish covers.

Figure 7. Detail of the engraved crest on one of the heater bases, below further details of the die-pierced motifs.

7. STANDING SALT CELLAR *Silver-gilt*

Marks: 1. London; 2. sterling silver; 3. 1856–57; 4. maker's mark of Robert Garrard (Grimwade, no. 2322) for R. & S. Garrard & Co., the underside engraved at a later date: "1 of 12" in an oval

Height: 7¼ in. (18.2 cm.); *width* 4 in. (10 cm.); *depth* 3⅜ in. (8.5 cm.)

Weight: 15 oz. 2 dwt. (480 gm.)

Accession number: 97.87

Provenance: Christie's, Geneva, 15 May 1995, lot 7.

Description and Construction
Cast, chased, and textured in the form of a youthful huntsman in eighteenth-century costume.

Figure 2. Detail of the reverse of the figure, showing a section of the huntsman's coat. Note the burnished powder flask in contrast to the textures of the coat's surface and buttonholes, which were achieved by the use of various chasing tools.

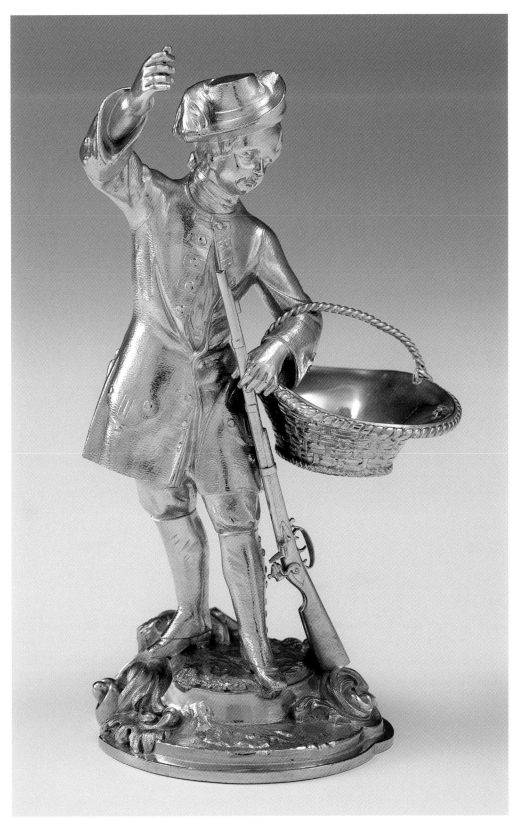

Figure 1. Silver-gilt standing salt cellar, maker's mark of Robert Garrard for R. & S. Garrard & Co., London, 1856–57.

8. PAIR OF STANDING SALT CELLARS *Silver and silver-gilt*

Marks: 1. London; 2. sterling silver; 3. 1866–67;
4. maker's mark of Robert Garrard (Grimwade, no.
2322) for R. & S. Garrard & Co., the bases stamped
"R & S. GARRARD PANTON ST LONDON"

Dutch Girl: height 6⅝ in. (14.3 cm.); *width*, 3 in.
(7.6 cm.); *depth*, 3½ in. (8.9 cm.)

Blackamoor: height 7 in. (17.8 cm.); *width* 3½ in.
(8.9 cm.); *depth*, 3½ in. (8.9 cm.)

Weight of Each Piece: 30 oz., 5 dwt. (936 gm.)

Accession numbers: girl, 97.83; blackamoor, 97.82

Description and Construction
Cast and chased, one in the form of a Dutch girl
in local costume, the other as a blackamoor hold-
ing a circular basin, the bowls with gilt interiors.

The addition to the Gans Collection of these charming figure salt cellars, together with
another, silver-gilt example, also from Garrard's,[1] raises the question once more as to the
source of their designs and models. Both Helen Clifford[2] and Joseph R. Bliss[3] have
addressed the subject, Dr. Clifford noting that the company's archives include a number
of relevant original sketches. Unhappily, however, these give no more information than
the names of the figures and that they were originally priced at £20 each.

While the Irish couple in the group, dating from 1855–56 and 1865–66,[4] have bases
conforming in design to those of their companions, the models for the figures themselves
are clearly not from the same hand. But Bliss remarks that they are of "immense impor-
tance . . . in the study and understanding of these silver figurines [because] they definitely
derive from nearly identical models which were shown together with two other salt cellars
at the Great Exhibition of 1851." These, bearing the London hallmarks for 1850–51, were
made in the workshops of the Parisian goldsmith Jean-Valentin Morel (1794–1860) during
his exile in London between the spring of 1849 and late 1852.

Garrard's use of Morel's figures is interesting, especially as they appear to have prompted
the company to commission one of its own artists to provide suitable designs and models
with which to extend the range. The same might have happened at Hunt & Roskell,[5]
Garrard's great rival, which certainly had access to Morel's 1850–51 models, but the firm
seems to have been content merely to copy them[6] rather than to elaborate on the theme.

Although a common source for these figures has eluded all investigations, it is highly
likely that the designers at both Morel's and Garrard's were inspired by prototypes made
in porcelain during the eighteenth century, such as those from the Chelsea factory in the
1760s. Nor should the silver statuette bearing the maker's mark of Frederick Kandler,
London, 1777, be forgotten.[7] In this rare example in silver, the figure of a milkmaid in
contemporary costume stands with a pail upon her head; the square plinth, decorated
with cast rams' heads and laurel leaf festoons, is further engraved "Nanny."

1. Standing Salt Cellar, cat. no. 7, acc. no. 97.87.

2. Julia Ogilvy, ed., *Royal Goldsmiths: The Garrard Heritage*, exhibition catalogue, Garrard & Co. Ltd. (London:
 Garrard, 1991), 84–86, nos. 42 and 43, entry by H. Clifford. British Library shelfmark YK.1993.b.4457.

3. Joseph R. Bliss, *The Jerome and Rita Gans Collection of English Silver on Loan to The Virginia Museum of Fine Arts*
 (New York: ARN Publishing, 1992), cat. nos. 74–76, pp. 216–23.

4. Cat. nos. 75 (girl, 1865–66), and 76 (both, 1855–56).

5. Successor to Storr & Mortimer, established by Paul Storr after leaving Rundell's Dean Street silver manufactory.

6. Two pairs of Hunt & Roskell silver figure salt cellars, one an eighteenth-century beau and his companion, the other
 the Irish boy and girl—all copied from Morel's originals, and standing on plain bases of his design rather than on
 those of a more decorative nature like Garrard's in the Rococo style—are recorded with the London hallmarks for
 1856–57 and 1865–66. (Sotheby's, London, 3 May 1984, lot 155).

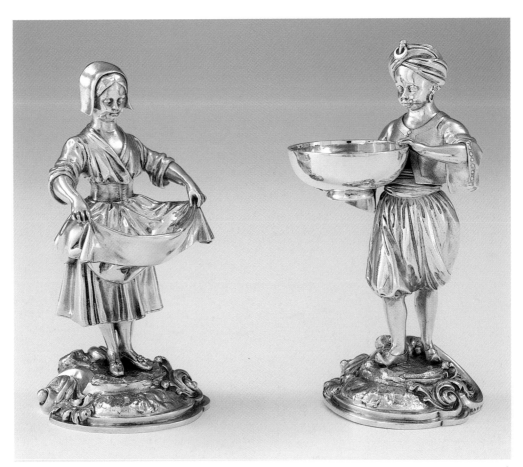

Figure 1. A pair of sterling silver standing salt cellars, maker's mark of Robert Garrard for R. & S. Garrard & Co., London, 1866–67.

Figure 2 (*left*). A detail of the cast head of the blackamoor figure with its fine textured surface.

Figure 3 (*below*). Detail of one of the bases, showing stamped label; "R & S. GARRARD PANTON ST LONDON."

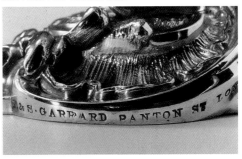

7. For an illustration, see Michael Clayton, *The Collector's Dictionary of the Silver and Gold of Great Britain and North America* (Feltham, N.Y.: Country Life, 1971), 286, fig. 576. There is some confusion upon the point, but it seems likely that this Frederick Kandler is the same individual as Charles Frederick Kandler who early in life was a modeler of figures for the Meissen porcelain factory. See Arthur G. Grimwade, *London Goldsmiths, 1697–1837: Their Marks and Lives from the Original Registers at Goldsmiths' Hall and Other Sources*, 3d ed. (London: Faber and Faber, 1990), 567.

Bibliography

Archaeological Journal. (London) 8 (1851): 197.

The Annual Biography and Obituary for the Year 1827. Vol. 11. London: Longman, Hurst, Rees, Orme, and Brown, 1828.

B[ankruptcy] 3/1257, Public Record Office, Kew, Surrey, England.

Barr, Elaine. *George Wickes: Royal Goldsmith, 1698–1761*. London: Studio Vista, Christie's, 1980.

Bliss, Joseph R. *The Jerome and Rita Gans Collection of English Silver on Loan to The Virginia Museum of Fine Arts*. New York: ARN Publishing, 1992.

Brasbridge, Joseph. *The Fruits of Experience, or, Memoir of Joseph Brasbridge, Written in his 80th Year*. London: Printed for the author, A. J. Valpy, 1824.

Bury, Shirley, and Michael Snodin. "Flaxman's Shield of Achilles." In *Art at Auction: The Year at Sotheby's, 1983–84*. London: Sotheby Publications, 1984.

Bury, Shirley. "The Lengthening Shadow of Rundell's." Parts 1, 2, and 3. *Connoisseur* 161 (1966): 79–85, 152–58, and 218–22.

Cartier, Nicole, and Isabelle. "The Elie Pacot Surtout." *Silver Society Journal* (London) 5 (winter 1994): 296–301.

Chaffers, William. *Gilda Aurifabrorum*. London: Allen, 1883.

Chambers, Robert. *The Book of Days. . . .* Vol. 2. London and Edinburgh: W. & R. Chambers, 1866.

Clayton, Michael. *The Collector's Dictionary of the Silver and Gold of Great Britain and North America*. Feltham, N.Y.: Country Life, 1971.

Clifford, Helen. " 'The King's Arms and Feathers': A Case Study Exploring the Networks of Manufacture Operating in the London Goldsmiths' Trade in the Eighteenth Century." In *Goldsmiths, Silversmiths, and Bankers: Innovation and the Transfer of Skill, 1550 to 1750*. Stroud, Gloucestershire, and London: Alan Sutton Pub., Centre for Metropolitan History, 1995, 84–95.

——. "Paul de Lamerie and the Organization of the London Goldsmiths' Trade in the First Half of the Eighteenth Century." In *Paul de Lamerie: At the Sign of The Golden Ball: An Exhibition of the Work of England's Master Silversmith 1688–1751*. Exhibition Held at Goldsmiths' Hall, . . . London, from 16th May to 22nd June 1990. Edited by Susan Hare. [London]: Goldsmiths' Company, 1990, 24–28.

——. "The Vulliamys and the Silversmiths, 1793–1817." *Silver Society Journal* 10 (autumn 1998): 96–102.

Culme, John. "Attitudes to Old Plate, 1750–1900." In *The Directory of Gold and Silversmiths, Jewellers, and Allied Traders, 1838–1914: From the London Assay Office Registers*. Woodbridge, Suffolk: Antique Collectors Club, 1987.

——. "Beauty and the Beast: The Growth Of Mechanisation in the English Plate, Plated and Allied Industries." *Connoisseur* 196 (September 1977): 44–53.

——. "A Devoted Attention to Business: An Obituary of Philip Rundell." *Silver Society Journal* (London) 2 (winter 1991): 91–102.

——, ed. *English Silver Treasures from the Kremlin: A Loan Exhibition . . . from 1st January 1991 to 28th January 1991*. [London]: Sotheby's, 1990.

——. *Nineteenth-Century Silver*. London: Hamlyn for Country Life Books, 1977.

De Castro, John Paul. *The Law and Practice of Hall-Marking Gold and Silver Wares*. London: Crosby Lockwood & Son, 1926.

The Directory of Gold and Silversmiths, Jewellers, and Allied Traders, 1838–1914: From the London Assay Office Registers. Woodbridge, Suffolk: Antique Collectors Club, 1987.

Exhibition of the Works of Industry of All Nations, 1851: Reports by the Juries. . . . London: William Clowes, 1852.

Gentleman Many Years Connected with the Firm. *Memoirs of the Late Philip Rundell, Esq., Goldsmith and Jeweller to His Majesty. . . .* London: J. Fairburn, 1827.

Gere, Charlotte, John Culme, and William Summers. *Garrard: The Crown Jewellers for 150 Years, 1843–1993*. London: Quartet Books, 1993.

Glanville, Philippa. *Silver in England*. London: Unwin Hyman, 1987.

Grieg, James, ed. *The Farington Diary*. Vol. 7. 4th ed. London: Hutchinson, 1927.

Grimwade, Arthur. *London Goldsmiths, 1697–1837: Their Marks and Lives from the Original Registers at Goldsmiths' Hall and Other Sources*. 3d ed. London: Faber and Faber, 1990.

Hall Marks on Gold and Silver Plate. 2d ed., much enlarged. London: Davy, 1865.

Hare, Susan, ed. *Paul de Lamerie: At the Sign of The Golden Ball: An Exhibition of the Work of England's Master Silversmith 1688–1751*. Exhibition Held at Goldsmiths' Hall, . . . London, from 16th May to 22nd June 1990. [London]: Goldsmiths' Company, 1990.

——. "A Tribute to Paul de Lamerie." *Silver Society Journal* 4 (autumn 1993): 160.

Hartop, Christopher. *The Huguenot Legacy: English Silver, 1680–1760, from the Alan and Simone Hartman Collection*. London: Thomas Heneage, 1996.

Heal, Sir Ambrose. *The London Goldsmiths, 1200–1800*. Cambridge, Eng.: The University Press, 1935.

A King's Feast: The Goldsmith's Art and Royal Banqueting in the 18th Century. Catalogue of an Exhibition Held at Kensington Palace, [London], 5th June–29th September 1991. Copenhagen: Den Kongelige Udstillings/The Royal Exhibition Fund, 1991.

Laker, Rosalind. *The Silver Touch*. London: Methuen, 1987.

"Letter-book of Dru Drury (1725–1803), 1761–1783, Being Copies, Nearly All in His Own Hand, of His Scientific and Other Correspondence." 96 q Biog. Entomological Library, Natural History Museum, South Kensington, London.

Morgan, E. D., and C. H. Coote, eds. *Early Voyages and Travels to Russia and Persia, by Anthony Jenkinson and Other Englishmen. With Some Account of the First Intercourse of the English with Russia and Central Asia by Way of the Caspian Sea*. Ser. 1, Nos. 72–73. 2 vols. London: Hakluyt Society, 1886.

Morgan, Octavius. *Table of the Annual Assay Office Letters*. London: Office of the Archaeological Institute of Great Britain and Ireland, 1853.

MSS 11936/440 809339 and 11936/448 836894. Guildhall Library, London.

Newton, Wilfrid Douglas. *London West of the Bars*. London: R. Hale, 1951, 164.

Nightingale, Joseph. *London and Middlesex; or, An Historical, Commercial, & Descriptive Survey of the Metropolis of Great Britain. . . .* Vol. 3, Pt. 1. London: Printed for J. Harris et al., 1815.

Ogilvy, Julia, ed. *Royal Goldsmiths: The Garrard Heritage*. Exhibition Catalogue, Garrard & Co. Ltd. London: Garrard, 1991.

Oman, Charles Chichele. *The English Silver in the Kremlin, 1557–1663*. London: Methuen, 1961.

Penzer, N. M. *Paul Storr: The Last of the Goldsmiths*. London: Batsford, 1954.

Rococo: Art and Design in Hogarth's England, 16 May to 30 September 1984, the Victoria and Albert Museum. London: Trefoil Books (for) The Museum, 1984.

Schroder, Timothy. *The Dowty Collection of Silver by Paul de Lamerie*. Cheltenham, Eng.: Cheltenham Art Gallery & Museums, 1983.

Tanner, Sarah. "A Man Who Never Was." *Silver Society Journal* (London) 2 (winter 1991): 89–90.

Venable, Charles L. *Silver in America, 1840–1940: A Century of Splendor*. New York: Dallas Museum of Art, distributed by H. N. Abrams, 1995.

Walpole, Horace. *A Catalogue of the Classic Contents of Strawberry Hill*. [London]: Smith and Robins, Printers.

Wardle, Patricia. *Victorian Silver and Silver-Plate*. London: H. Jenkins, 1963, and New York: Universe Books, 1970.

Wees, Beth Carver. *English, Irish, & Scottish Silver at the Sterling and Francine Clark Art Institute*. Williamstown, Mass. 1st ed. New York: Hudson Hills Press, 1997.

Williams, Clare, trans. and ed. *Sophie in London, 1776: Being the Diary of Sophie v. la Roche*. London: J. Cape, 1933.

Williamson, Captain A. R. *Eastern Traders: Some Men and Ships of Jardine, Matheson & Company. . . .* N.p., Jardine, Matheson & Co., 1975.

Young, Hilary. "Thomas Heming and the Tatton Cup." *Burlington Magazine* (London) 125 (May 1983): 285-89.

Index